Ken Thomson The Collector

THE THOMSON COLLECTION
AT THE ART GALLERY OF ONTARIO

Ken Thomson The Collector

THE THOMSON COLLECTION
AT THE ART GALLERY OF ONTARIO

Edited by Conal Shields

SKYLET PUBLISHING /
THE ART GALLERY OF ONTARIO

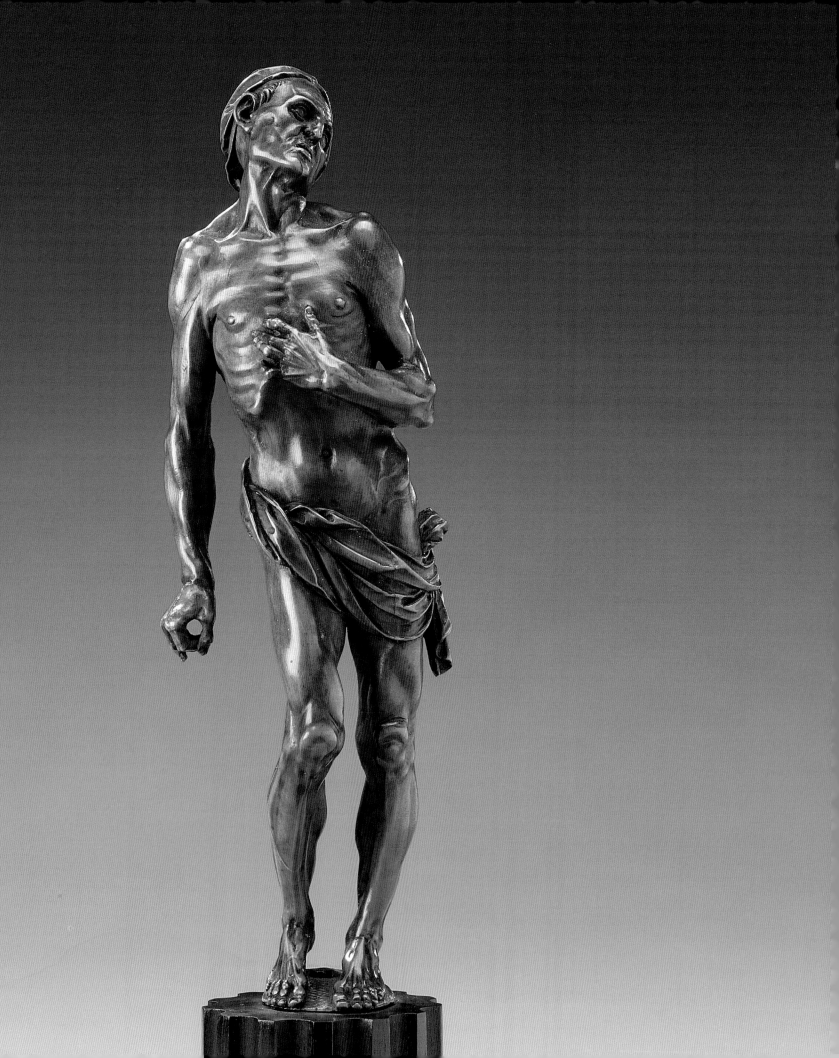

Contents

Foreword

KENNETH ROY THOMSON, 2nd Baron Thomson of Fleet, or Ken as we all knew him, was an extraordinary human being. He built upon his father's legacy to construct one of the most successful global business empires. He amassed with an ever-growing passion what is undoubtedly the finest collection of art ever in private hands in Canada. He was the catalyst for and the enabler of Transformation AGO, and he still retained the common touch. Ken derived great joy from his interaction with people from all walks of life – whether pointing out to total strangers intriguing bargains at the local Loblaws, or sending a photograph (perhaps not of museum quality) he had taken of you with his basic camera at an event the night before.

At a lunch following a TD board meeting after Ken flipped one of his brightly coloured signature ties over his shoulder to avoid attracting the soup of the day, I asked him how he became interested in art. He began seriously collecting in 1953 when he spotted two miniature ivory busts in a Bournemouth antique shop. Shortly thereafter, Ken became excited by the prospect of acquiring an exquisite boxwood figure and was admonished by his advising dealer: "You must not look like that when you see it. You must control yourself and look very solemn. You will put the price up with enthusiasm like that." Ken took the advice to heart, but it was an enduring struggle to restrain his natural enthusiasm for marvellous works of art.

Over the years, Ken developed an ever more discerning and refined eye, but his guiding rule in acquiring art was, "If your heart is beating,

you know it was made for you." I remember Ken confessing that, while assembling his collection, he viewed the Art Gallery of Ontario as a competitor but, as time passed, he came to envisage the AGO as the ideal vehicle for keeping the collection intact and exhibiting it to the people of Canada so that they could experience the same pleasure as he did from his art. "It might make people see and enjoy objects previously unfamiliar to them. . . . It might open up their horizons. I do not see how you can walk past these beautiful objects, look at them, and not see the glory of art and its creation." Accordingly, Ken determined to donate his unsurpassed collection and to work with Matthew Teitelbaum and Frank Gehry to transform the Art Gallery of Ontario.

Ken wanted the works displayed in an atmosphere where the viewer could feel "at home." At one time, he contemplated music in the galleries, and he liked the idea of a series of rooms that led one into the other so that people could walk through "chapters" of his collection.

Ken remained intimately engaged in the Gehry project to the end. He continued to purchase works of art to enhance the quality of the Thomson Collection and with exceeding generosity took steps time after time to encourage the realization of Transformation AGO at the highest level. I remember Ken leaning over at a curatorial discussion of the David Milne exhibition in 2005 and saying, "I don't want to jinx it, Charlie, but I think our project is going to be the best." That seemed appropriate, because everything about Ken Thomson was the best.

A. CHARLES BAILLIE, O.C.
PRESIDENT, ART GALLERY OF ONTARIO

The Collector

MY FATHER MADE SENSE of the world through objects. As a young boy I remember the intimacy of those moments.

Saturday evening after our routine visit to Portobello market, he would sit on the living room floor dressed in faded blue pajamas, legs splayed. A heavily worn, cardboard light-tube box was opened in the gap between. An array of gold pocket watches lay within, each with their own cloth case or plastic pocket and small labels or notes that described every detail about their acquisition. My father would handle each watch with intense deliberation. The mechanism would be wound and the case often opened from the back to expose all the moving parts. An infinite variety of chimes would break the tempo of the TV and we rather accepted the intrusion as part of the rhythm of our family life. My father was completely transfixed and would allow himself to be overtaken by feelings of the moment. The poignancy of the above memory resonates above all others. The action was so natural and merely an extension of those human interactions that we witnessed as children on a daily basis. Father's capacity to embrace the world with a sense of wonderment was a constant source of inspiration. Over the years a myriad of similar moments occurred in the presence of art and one yearned for an opportunity to take a similar pathway.

Memories of my father yield endless pleasure. If any of these settle beyond a moment, they likely touch the realm of art. His passion was derived from an innate curiosity about the world; a desire to be drawn into the lives of those individuals, either makers or observers. My father sought

a visceral response. Scale mattered, as did material. The objects that stole his heart were intimate and could be handled with ease. The medium seemed irrelevant – a sixteenth-century boxwood prayer nut, a seventeenth-century anatomical drawing, an early nineteenth-century miniature bone ship model, or a Tom Thomson panel from the spring of 1917. The artist's presence lay within each object and the dialogue was intense.

I cherished my father and our communion derived from art. Shared experience drew us closer to one another and the creative universe inspired a process of constant discovery and self-revelation. Competition within the marketplace fired our basic instincts and propelled us forward. The quest at times seemed like reckless abandon, but it did constitute a matter of life and death. As we previewed auctions, or considered objects in the trade, father would allow himself to commune with each piece in the most touching way. The hands, eyes and facial expression always betrayed a sense of wonderment. One became transfixed by this humble and gentle spirit that could engage so deeply with these small objects. In the moment of engagement my father's shoulder would make contact with my own along with a deep sigh of incredulity.

A seminal moment was surely our visit to Liechtenstein in the early 1970s during a business commitment. The family was young and we all experienced father's complete enrapturement with the Rubens paintings in the Princely collections. None of us was prepared for the aftermath. My father extolled the virtues of the artist and was completely baffled by their

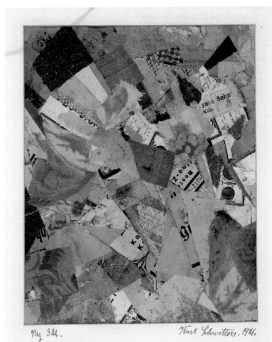

extraordinary impact. As one listened to the language and tone of voice, one wondered, could there ever be a work of art that meant more to my father? The *Massacre of the Innocents* was the unbroken thread back to this moment that had made such a profound impact upon all of us. For my father, the opportunity to acquire lot 6 on July 5, 2002 represented the culmination of a life's journey in the visual arts. The act truly celebrated his nature and ran completely counter to the assumptions of a greater world.

From an early age I too began to collect. Our journeys ran in tandem. One day father alighted upon a 1921 Kurt Schwitters collage hanging in my bedroom. The assemblage of discarded debris across its surface transfixed his gaze. The work hung in my room, but at this moment it truly touched a chord within him. The collage was entitled *Bunt* and was to remain in his bedroom from that day. Father took away several catalogues and would always recount fragments of Schwitter's life thereafter.

My privilege was to bear constant witness to those passionate interfaces with works of art. Journeys can often be solitary and the objects gathered along the way can represent a material rather than an aesthetic value. Father's course was shared openly with others on an almost daily interface. Art and business ran parallel. Colleagues could exhibit selfless devotion or absolute self-interest, but the art survived unscathed. The sheer aesthetic experience elicited gesture, language, expression and forced emotions to the surface. Each encounter was distinctive and reflected the unique nature of countless objects. States of being became

hallucinatory and the spectacle held a young man spellbound. The act was considered and reverential. One sought similar experiences in one's own universe. That universe was about possibility – a region of kindred spirits and mutual respect. Centuries suddenly telescoped and the full aspect of humanity registered anew. The desire to participate overcame all else, as one embarked upon a quest to make sense of the world and share the delight of illumination. The pursuit of art symbolized hope amidst the complex wounding vicissitudes of life.

My father's greatest achievements were forged entirely within the realm of human relationships. The Collection exists as a testimonial to a journey undertaken in the company of others. The film documentary we have made, which touches upon this aspect, seems a natural occurrence. The weight of collective memory equates to the objects themselves and imbues them with the widest spectrum of meaning.

Too seldom do we experience the human overlay which makes all possible. Although so personal, my father's process of discovery deserves a wider audience. If a legacy endures, surely the quest for self-illumination and discovery rests above all else. My father's life course celebrated innumerable human encounters, each one inspired and distinct. The works of art increasingly became the vessels through which he understood his own world and that of others. Every one of us would do well to embrace the same sense of purpose – unqualified, direct and without parameters to constrain those innermost yearnings of the soul.

DAVID THOMSON

Ken Thomson Collector A Valediction

CONAL SHIELDS

Urbane in manner, straightforward in utterance yet unfailingly courteous, diffident to a degree when it came to the expression of his emotions, Ken Thomson – the second Baron Thomson of Fleet and Northbridge – was everything positive connoted by the term 'gentleman.'

There were, however, strong feelings beneath the gentlemanly surface (perhaps hinted at by Ken's habitual flamboyant choice of tie!) and these, rather than simply a relish for acquisition, drove a lifetime of collecting. About his family (not forgetting the dogs) and about the business with which his father had entrusted him, he could in private speak with a warmth and even a passion which would certainly have surprised those who knew only his public *persona*. And nobody who saw him handle a Byzantine ivory or a medieval casket, who saw his face light up while peering into the incidental virtuosities of a fifteenth-century portrait painting, could doubt the strength of his engagement with what were clearly to him much, much more than rare and costly objects. Collecting was a thrill and he wrote of trembling as he lifted an object down from its shelf. I once stood beside him as he cut short the hyperbole of a leading gallery proprietor with the words: "You seem to like it, but it says nothing to me, it does not speak to my heart." In a variety of ways, everything he collected had thus to address him. On the same occasion, I might add, he showed a familiarity with the genre in question, including details of manufacture, and a knowledge of the collecting field which left his companions open-mouthed. But the need for an emotional link was paramount and once this was established the effect could be transforming. As his son David says, "Picking up one of his favourite objects he was enveloped by its aura and became a different person."

Ken's character may therefore, to an extent, be read in what he collected. And the principal elements in the make-up of his taste were, it seems to me, entirely consonant with his attitude to the world at large. He recognized and celebrated emotional intensity, and intellectual ambition too, but valued above all the ability to contain and to make coherent potentially disruptive impulses. He was fascinated by the direction of raw need into positive structure, and the greater his understanding of the risks of creative processes the greater his respect for an object which emerged from them. As Sam Fogg, the longest serving of his art advisors, says, with all Ken owned, whether of immense historical importance and high value or distinctly humble, he had an intense relationship. It was invariably the case, too, that he got a real thrill from entering art's community of interest, and those with whom he could talk about art were amongst his closest friends. Between Ken and his advisors there was two-way traffic but he never hesitated to keep his own counsel. Sam says, "Everyone I know enjoyed . . . selling . . . to Ken, even if they were unsuccessful. I myself suffered the frustrations of very long and sometimes agonizing and ultimately fruitless negotiations . . . but I always looked forward to seeing him again."

The Thomson Collection finally ranged from ancient Egyptian artefacts, through early Christian and medieval sculpture, the painting of Renaissance Europe, Baroque *objets de luxe* and the art of eighteenth- and nineteenth-century England, ship models of many kinds, to Canadian works of the nineteenth century and the modern period. Ken's taste, of course, developed over time. But certain characteristics and qualities were always of compelling interest to him.

There are in the Collection many obviously well-made things. For example, painted miniatures and ship models alike demonstrate manual dexterity at the highest level. But Ken was unusual in appreciating the variety and depth of feeling which such extreme skills embody. In the main the craftsman and what he brings forth are nowadays regarded as emotionally neutral. To Ken craftsmanship was an important aspect of the effective control of an individual's sensibility, each of its finest products a case of inchoate matter translated by means of an all too human struggle into meaningful form. I am sure that an awareness of the problems of representation in general and the extra challenges which face the artist who seeks to capture specific likeness informed his response to the former, and I suspect that a keen sense of the sea and of the difficulties of the life lived upon it underlay his delight in the ship-modeller's mastery. Here, I know, he judged the quality of the thing made against the scale and complexity of what he imagined to be the problems taken on, both in the often abrading experience which lay behind it and in the operations required for its production: he detected the maker's personality within the technical distinctiveness of the solution on offer.

Ken Thomson's death was sudden and unexpected. He had said that he would go on for another seven years and so used were friends and colleagues to his authority that this was simply taken for granted. A number of pieces in the Collection suggest that the fact of human fragility and of its ultimate inconsequence was real to him. Amidst the spectacles of legerdemain and the displays of luxurious materiality *memento mori* sounds a chastening note. The sequence of skulls, in wood, bone, ivory, silver and gold, is a very obvious pointer to a constant awareness of human frailty and the vanity of human hopes. If seen rightly, and Ken's vision here was right enough, a qualification of any concern with earthly achievement runs through Christian art in general. Many of the paintings and many of the sculptural works, at least those from Western Europe, which Ken owned employ a naturalistic image to prompt thought about the imminence of another and supposedly more substantial realm, the realm of super-nature and, ultimately, of God's mind. The Christian artist's purpose, to which Ken was certainly sensitive, was to challenge acceptance of everyday existence and to allow glimpses of a superior, archetypically real and permanent state.

I mention such matters to help establish what I am sure was a fact in Ken's case. His Collection was no mere show of wealth, never simply an instance of trophy-gathering on the grand scale, but a major resource in the pursuit of a satisfyingly thoughtful and coherently emotional life. His office in Toronto opened into a suite of rooms replete with what he could regard as the most interesting, thought-provoking yet consolatory works from the Collection. It allowed him to step aside from the fraught game of high finance, and to experience vicariously the concerns of other people, other times and places, to measure his own sense of the world against the construction which an unusually skilled craftsman or an exceptionally gifted artist had put upon his situation. I do not for a moment doubt that the orderliness which Ken continuously sought, a constant wish for the shapely resolution of problems, conditioned his predilections in art; nor do I doubt that the payback was vital to him.

Even in areas of interest which seem at first somewhat remote from the kind of need to which I have referred there is, on reflection, a centrally important component of problem-solving. By his own account, Ken's collecting began with the purchase of a pair of Cheverton busts (fig. 1). Intrigued by their elaborate neatness, he quickly learned that they were the products of technical ingenuity. The Victorian sculptor Benjamin Cheverton had modified the pantograph, a device for reproducing drawings on varying scales, so as to do the same job in three dimensions. Thus a life-size portrait bust could by means of the Reducing Machine be diminished to a version only inches in height. The interest in ways and means of manufacture remained with Ken for the whole of his collecting career and a concern with the descriptive and expressive purposes which they could

serve was soon to get under way. It must be, indeed, the awareness of how an object's content, its body of meaning, arises from and is, to an extent, determined by the materials and methods available to its maker that Ken, modestly as he put it, was talking about when he said to Matthew Teitelbaum, in 1997, "my eye and taste have become more refined." In my experience, conversations with Ken about the contents of the Collection always took in issues of subject, and usually touched on the relationship of themes and topics to the manner in which these were realized.

There are in the Thomson Collection sculpted portraits of a very superior kind. David Le Marchand's ivory relief of Sir Isaac Newton (fig. 2), for example, is the most convincing image of the natural philosopher and

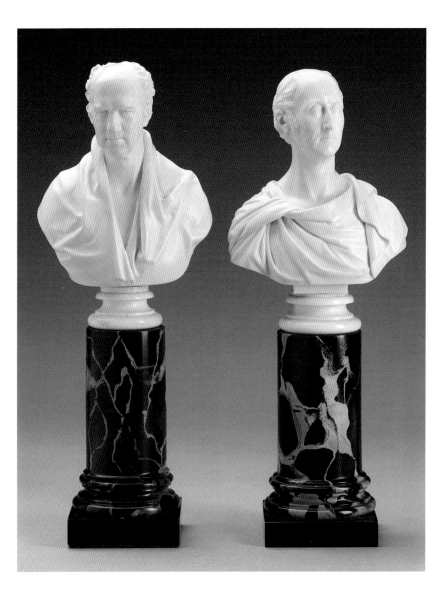

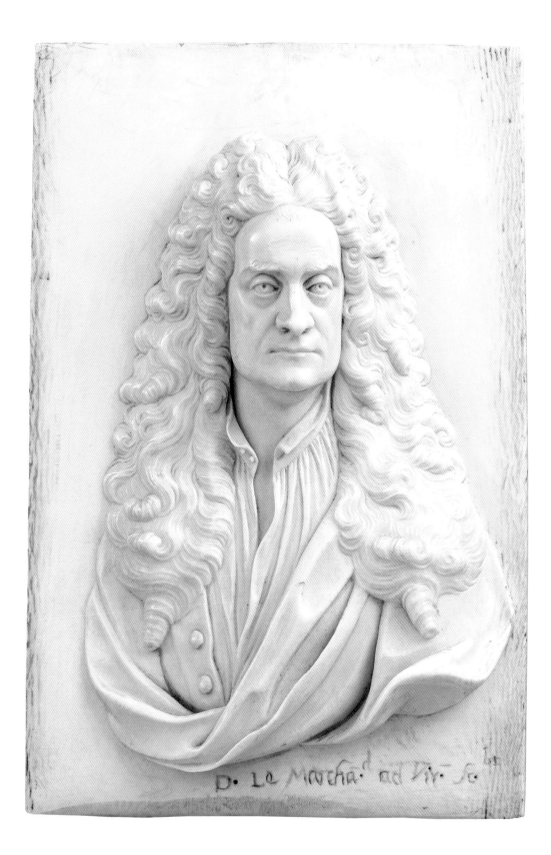

D. Le Marchand ad Div. Sc.

3
Ken's medieval ivories under
examination by Professor
John Lowden in the Prints
and Drawings Room of
the Courtauld Institute

4
**Diptych with the Nativity
and the Last Judgement**
Paris, c. 1300
Height 182 mm
width 133 mm (closed)
268 mm (open)

mathematician to survive, whether or not it is indeed the only one from the life. The emergence from this relatively intractable material of an all too human head, with the hairs of its full-bottomed wig nicely distinct from the fabrics of shirt and coat, seemed to Ken a near magical act. Ken said that holding such a piece in his hand gave him something of the sensation which the artist would have had while looking over the completed assignment and allowed him to recreate in his mind the impression which the famous and, we are told, remote sitter made upon a contemporary. Ken was capable of considerable subtlety and imaginative projection in his reading of an art object.

The small size of these portraits, and of much else in the Collection, was important. On occasion Ken went for what Walter Scott called "the big bow-wow," the address at full throttle of an elite by an acknowledged art grandee. As a rule he preferred quieter voices. In their presence he could, to quote the last of his specialist advisors, "get close up and personal." The definition for himself of a thing's characteristics and the discovery for himself of its qualities were important. It is not fanciful to say that in Ken's case familiarization with any object involved the definition and discovery of self. The refinement of his perceptual powers and the development of the ability to project imaginatively were perhaps the most enjoyable aspects of the collecting game.

A good deal of Ken's taste for art was focused on the Middle Ages and he was fortunate to own a number of outstanding medieval ivories (fig. 3). Two of these occupied a special place in his affections and they are, by any measure, wholly extraordinary. The three-register Dormeuil Diptych (fig. 5), probably made in Paris c. 1350–75, is literally crammed with dramatic incident and narrative detail. Examining now the scenes of the Passion story, I can recall Ken speaking of the Paris master's utterly compelling creation of a small but diverse world, where elegance of handiwork contrasts to painful effect with the grim inevitability of Christ's progress to humiliation and death. Such details as the heads of the two comforting women, which seem simultaneously to crane towards and to recoil from the Virgin in her shocked state. Or the trees in the Garden of Gethsemane, which writhe between the sleeping Disciples, both pointing up their comatose condition and opening the mind of the spectator to the drama ahead, Christ's betrayal and the Crucifixion. I remember Ken's enthusiasm for the sure choreography of the diptych's sizeable cast, the infinitely suggestive interconnectiveness of the tiny *dramatis personae*, and his conviction that only depth and complexity of spirit could have guided the artist's hand. In this and its companion pieces Ken was able to see, and to experience vicariously, emotions which were quite outside his everyday existence.

Sam Fogg, who was his principal advisor on medieval artefacts, rightly says that Ken Thomson was not in the traditional sense a connoisseur. Yet if he never, of his own accord, delved into scholarly controversy, he did

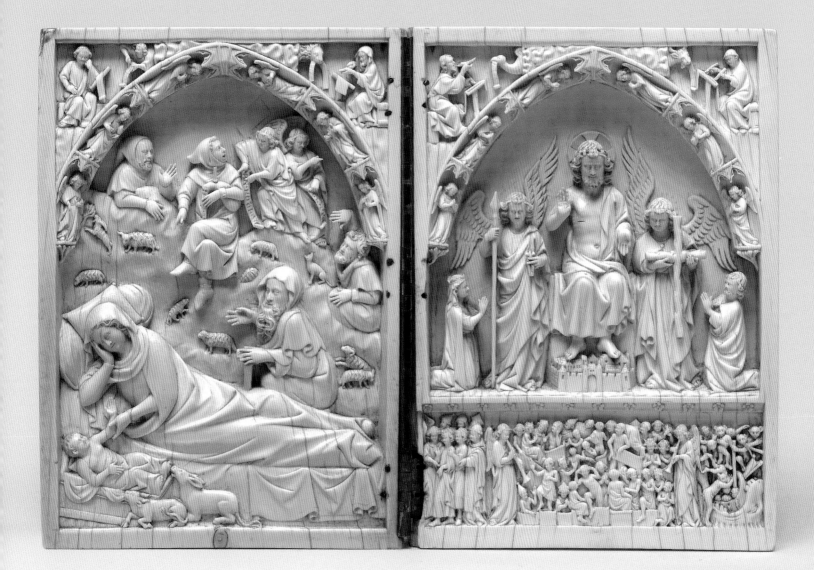

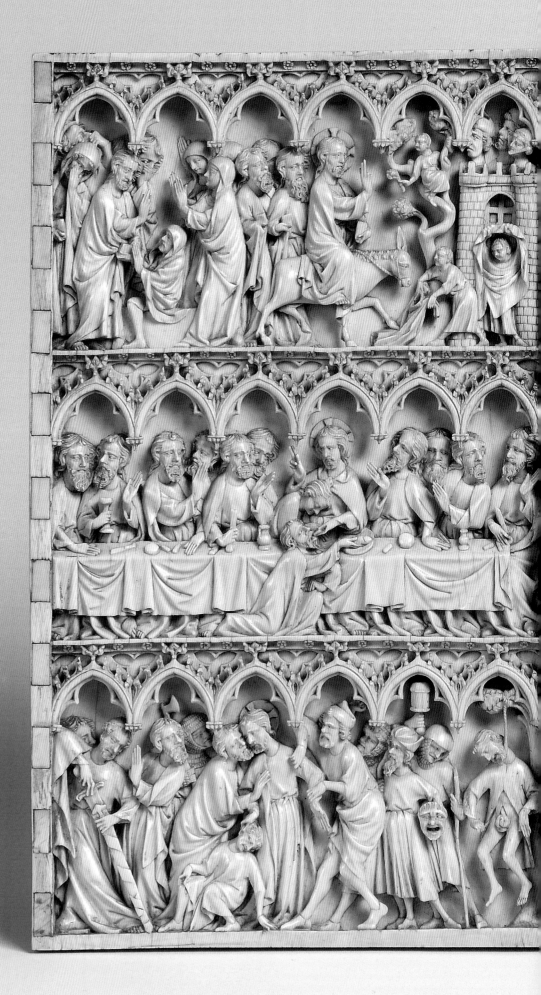

5
The Dormeuil Diptych
Paris, c. 1350–75
Height 251 mm,
width 156 mm (closed)
311 mm (open)

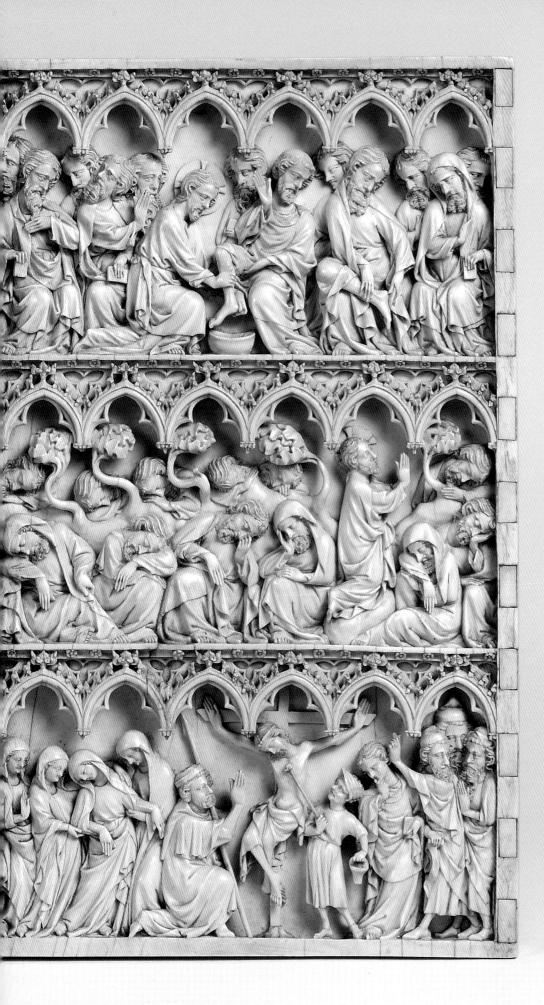

6

ISAAC OLIVER
(c. 1594–1647)
Mrs Cam of Newport
(front and back), c. 1610
Watercolour on vellum
73 × 51 mm

appreciate the fruits of scholarship when these illuminated a specific work. One of his last purchases was an ivory diptych, the largest of its kind, which has been called by the specialists currently studying it "the too good to be true" diptych (fig. 4), because carbon-dating shows the material to date between the mid 11th century and the early 1200s while twentieth-century scholars had hesitated to believe it was medieval at all. In so far as the thrust of debate concentrated attention on the knowledge and skill which the piece displayed Ken could closely attend to it. The extraordinary plasticity of the figures, the anatomical sophistication, the compositional fluency, delighted him, and in tracing these out he once again began to identify with the maker and to realize to an extent the sensations, the wants and needs which had prompted the creative processes before his eyes.

A large group of English miniatures is amongst the great glories of the Collection and has few peers. I have seen Ken quietly revelling in the mimetic expertise of Nicholas Hilliard (see figs. 61, 62, 63) or Isaac Oliver (fig. 6), while the miniaturists of the late eighteenth and early nineteenth centuries (figs. 7, 8) drew appreciative gasps from him. Peering at the small painted discs or squares and moving back and forth in his mind from a perception of technical refinements – and a grasp of the ways in which an individual's oddities of appearance and manner had been captured – to an almost electric sense of the artist's own personality, Ken was taken out of himself: his involvement was palpable.

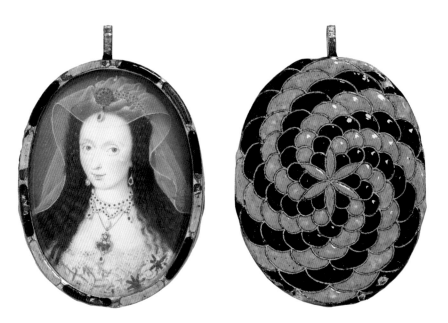

7
GEORGE ENGLEHEART
(1750–1829)
Portrait of a Young Lady
1807
Watercolour on ivory
86 × 69 mm

8
HENRY BONE
(1755–1834)
after WILLIAM BEECHEY
(1753–1839)
James Watt (1736–1819)
1803
Enamel on copper
200 × 170 mm

But he could find enlightenment in rather humbler efforts. One of the most striking aspects of Ken the collector was his penchant for artisanry as distinct from artistry. He was, it seems to me, often touched to the quick by what was honest even when true inspiration was lacking. Ken had been a brilliant performer at university and retained until the end his ability to take the point of an argument and to judge it shrewdly. A well-wrought case, however minor the issue at hand, always gave him pleasure. He enjoyed thorough-going craftsmanship because it told him that dedication to a job might be sought and found in the world at large and that the construction of a shapely and orderly world-view was possible for those who were skilled but not supremely gifted. Ken had at some stage, I am told, tried his hand at modelling and found he was not, in this at least, a high achiever. But the modelling exercises may have been enough to sensitize Ken to the labour, the lengthy course of trial and error, the honing of manual dexterity which went into a craftsman's practice. Craft at a high level commanded his respect and affection.

9
Troop landing craft
'Georgian' model,
Britain, *c.* 1755–60
Wood, brass,
putty/plaster(?)

10
GEORGE STOCKWELL
British two-decker
50-gun warship, *Bristol*
'Georgian' model,
Britain, 1774
Boxwood, ivory, glass

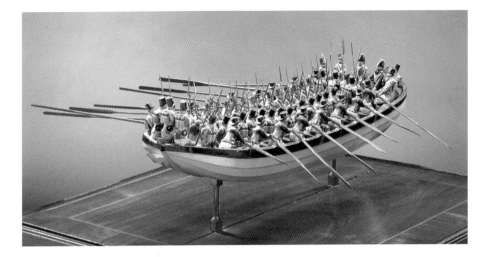

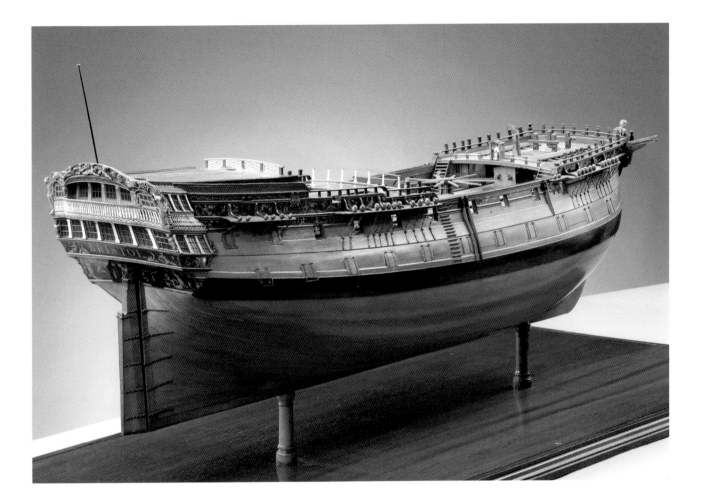

Ken laughed as I told him that Turner had once rebuked Ruskin for running down a jobbing painter with the words, "You don't know how hard it is," and the laughter signalled his agreement with the rebuke.

Ship models form a sizeable and significant part of the Thomson legacy. Some of them are patently journeyman works; most, though, are from the upper reaches of modelmaking, and among these are truly superb specimens, masterpieces of this very specialized area of creative activity. A small clinker-built landing craft (fig. 9) summed up to Ken the precarious, ever-threatened nature of the waterborne life, allowing him to imagine the apprehensions of men braving both the elements and the prospect of military engagement. It is a relatively humble example of the modeller's art. The Admiralty model of the 50-gun warship *Bristol* (fig. 10), on the other hand, is one of the very finest of all such things. Examination of the interior by means of illuminated optical fibre tubes revealed a scrap of paper (fig. 11) bearing the name of the maker, George Stockwell, and the date 1774. Thence was established a connection with a whole series of documents from the Royal Naval Dockyard at Sheerness and, with similar discoveries in another vessel, it became possible to reconstruct the career of the leading ship modeller of the period. That in turn prompted fresh thought about the function of models in the context of contemporary naval engineering and warfare. So Ken could ruminate in multiple dimensions, so to speak, when he bent down to gaze at the *Bristol*, and his awareness of its beauty was thoroughly informed. At one and the same time he came to understand and love the extraordinary facility with which individual units, a ship's rib, a section of planking, a tiny figurehead had been carved, to conjure up a mental picture of the maker and to see him as somebody responding to the emotional, practical, professional imperatives of his situation. And on top of this he could see in his mind's eye the ghostly

11
Bristol scroll bearing the name of the maker, George Stockwell, and the date 1774

This model was made may the 7: 1774 By Geo Stockwell Shipwright at Sheerness Yard

This slip of paper, rolled in a tight scroll, was found inside the hull of the Navy Board model of H.M.S. BRISTOL during restoration work in June 1992. The model was made by the shipwright George Stockwell of the Naval Yard at Sheerness from which the BRISTOL, a 50-gun 4th-rate, was launched on 25 October 1775. There is one other known note placed in a model by Stockwell.

12
Steam gold dredger
Builder's model, scale: 1:48
Britain, *c.* 1890
Wood, metal, glass, sand

shapes of mariners, captains and crews, moving around the miniaturized settings of action at sea.

For several of the models a fairly full context was realizable, allowing Ken to see them as reduced-scale versions of chapters in the human story, filling out an image of different occupations in a variety of historical circumstances and, it is not fanciful to claim, giving substance to an external world from which his economic and social position excluded him. The marvellous gold dredger of about 1890 (fig. 12) incorporates on board a whole factory in the minerals trade, the extraction of raw materials from a river bed, crushing and sorting processes leading at last to the unloading of sellable ores into the attendant barge. Again, the rock breaker of 1924 (fig. 13) is a complete and coherent model of a commercial system, evoking the physical, industrial and economic sector in which it operated. To notice the fine detail of its machinery is to appreciate the terrain it worked, the life-mode of its workers, and the specialized markets which it served.

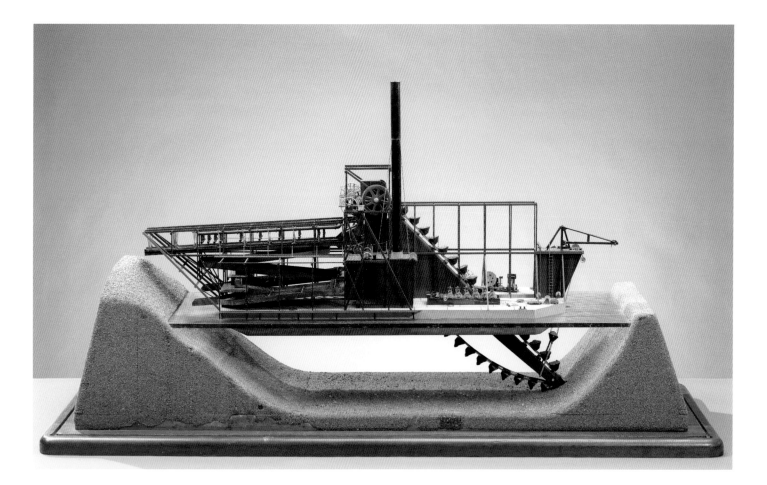

Ken Thomson Collector: A Valediction

13
Steam rock breaker
Builder's model, scale: 1:48
Britain, 1924
Wood, metal, stone

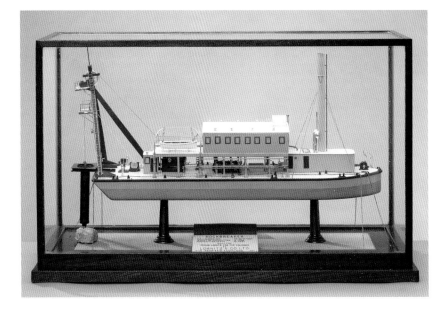

Perhaps the most readily comprehensible clue to the symbiosis of collector and Collection lies in the vast, unprecedented and still unparalleled accumulation of Canadian paintings. Ken was brought up to be patriotic and a nostalgia-inducing three years at Cambridge University sharpened his desire to identify with the homeland. But for such an identification to be richly resonant and deeply meaningful Ken required the mediation of those whose own ideas and emotions had been wholly engaged by the Canadian scene. In the mid-nineteenth-century painter Cornelius Krieghoff was to be found, Ken supposed, an upfront, sentiment-filled but unsentimental view of the Canadian situation in a distinctive native guise. Ken was moved to laughter, and almost to tears, by Krieghoff's *Breaking up of a Country Ball in Canada, Early Morning* (fig. 14). Here he saw an honest if relatively unsophisticated depiction of men and women enjoying the country of their birth. I do not doubt that Ken's notion of the Canadian countryside as a place to be loved was always coloured by Krieghoff's tableaux. He knew, of course, that Krieghoff was German-born, Dutch-trained and had spent much of his career in Europe and the United States. But the very want of European pictorial rhetoric in his pictures, their patent guilelessness, seemed to guarantee the integrity of what Ken came to regard as near-reportage.

A preoccupation with the peculiarities of Canadian locations and incidents which minimized or overrode European visual habits was usually the *sine qua non* of pictorial art to Ken. Tom Thomson was the favourite of the native artists he collected (see figs. 111–20). Thomson's vision seemed

14
CORNELIUS KRIEGHOFF
(1815–1872)
**Breaking up of a Country Ball in Canada,
Early Morning (The Morning after
a Merrymaking in Lower Canada)**, 1857
Oil on canvas
60.9 × 91.3 cm

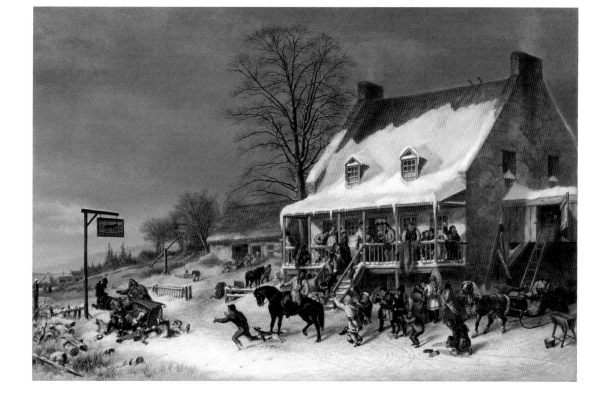

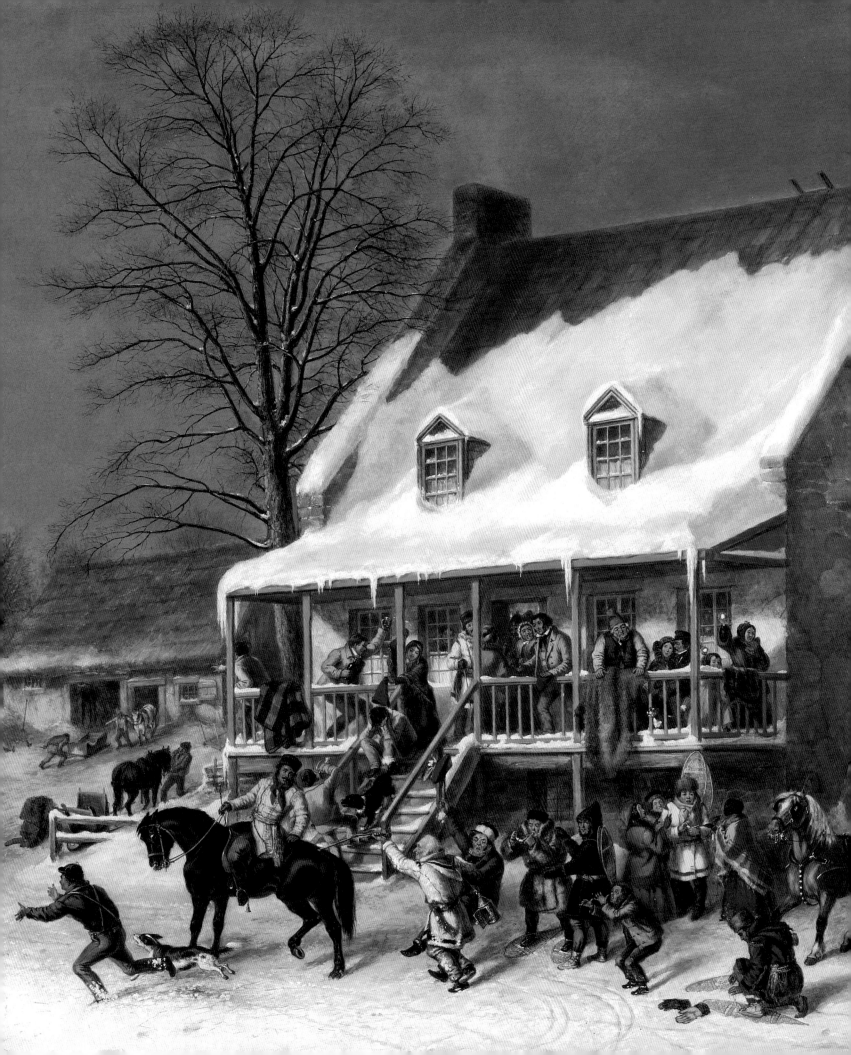

15
LAWREN STEWART HARRIS
(1885–1970)
Lake Superior III, *c.* 1923–24
Oil on canvas
102.5 × 127.6 cm

to embrace the Canadian landscape with no more than sporadic nods to European precedent. He was, it appeared, nakedly responsive to the light and colour, the textures and rhythms of his surroundings, ready to register the wildest hues and forms. And yet – essentially to Ken – he had evolved, through the continuous strengthening of a natural taste for pattern, a mode of pictorial containment: what would otherwise have been mere riotous assembly was brought into a condition of discipline without losing force. This, I think, was what Ken meant by creative tension.

For all Ken's attachment to other Canadians – his holding of the Group of Seven was the largest anywhere – Tom Thomson led the field where painters were concerned. That attachment, however, went from strength to strength. A measure of this is indicated by the prices Ken was prepared to pay. He said to me – and I cannot have been the first to hear it – "Anybody who pays the asking price is a fool or insane." Yet he raised the market profile of national art to previously incredible heights. The purchase in 1999 of Lawren Stewart Harris's *Lake Superior III* (fig. 15) for $1.6 million broke by some distance the record price for a Canadian picture.

However, for all his devotion to the painting of his own country, Ken was alive to European achievements in the medium. He owned

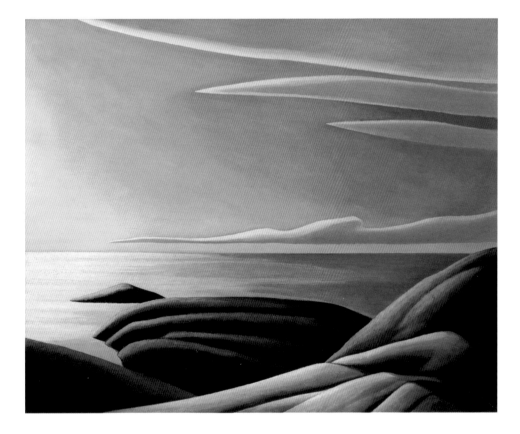

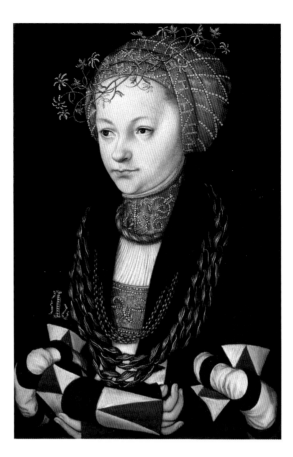

and enjoyed a clutch of eighteenth-century English portraits and took immense pleasure in the possession of strikingly accomplished works from Renaissance Germany and the Flanders of the early Baroque period. I was Ken's advisor on the acquisition of a portrait by Lucas Cranach (fig. 17), supposedly of Margaret of Anhalt, wife of Elector John the Steadfast, but which the uncovering of a date after conservation (fig. 16) has returned to anonymity. I well recall carefully reviewing, during the negotiations, what I thought I knew of Ken's likes and dislikes. It was then, indeed, that the image of Ken the collector which I have sketched above came into clear focus. At last I said to him: this picture is world-class and it abounds in features which you admire. There is, first and foremost, a fascination with the individuality, the idiosyncrasy, of each component; the costume is as intensely scrutinized and minutely depicted as the sitter's face; the elliptically swinging necklaces, the pale shoulder-wrap throwing into relief the brightly patterned dress, the head crowned with a turban which seems a little too tight for comfort, cautious eyes, that nose with its pert bulbous tip, the taut cupid's bow of a mouth, an incipient double chin constrained by the stiff neckband, and, emerging in a rictus

18
PETER PAUL RUBENS
(1577–1640)
The Massacre of the Innocents
c. 1610–12
Oil on panel
142 × 182 cm

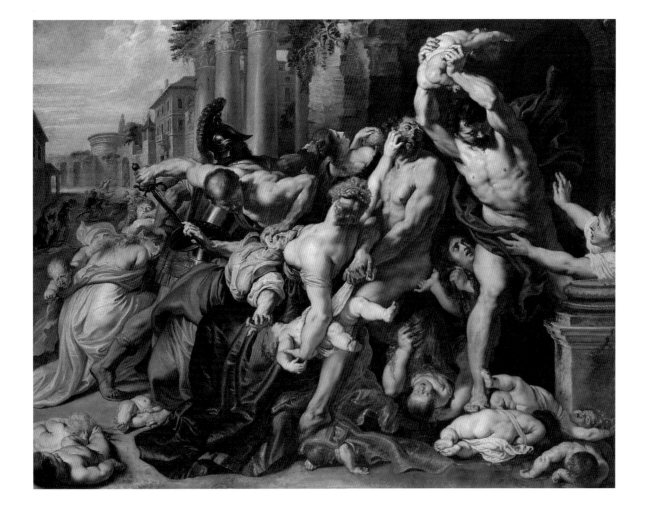

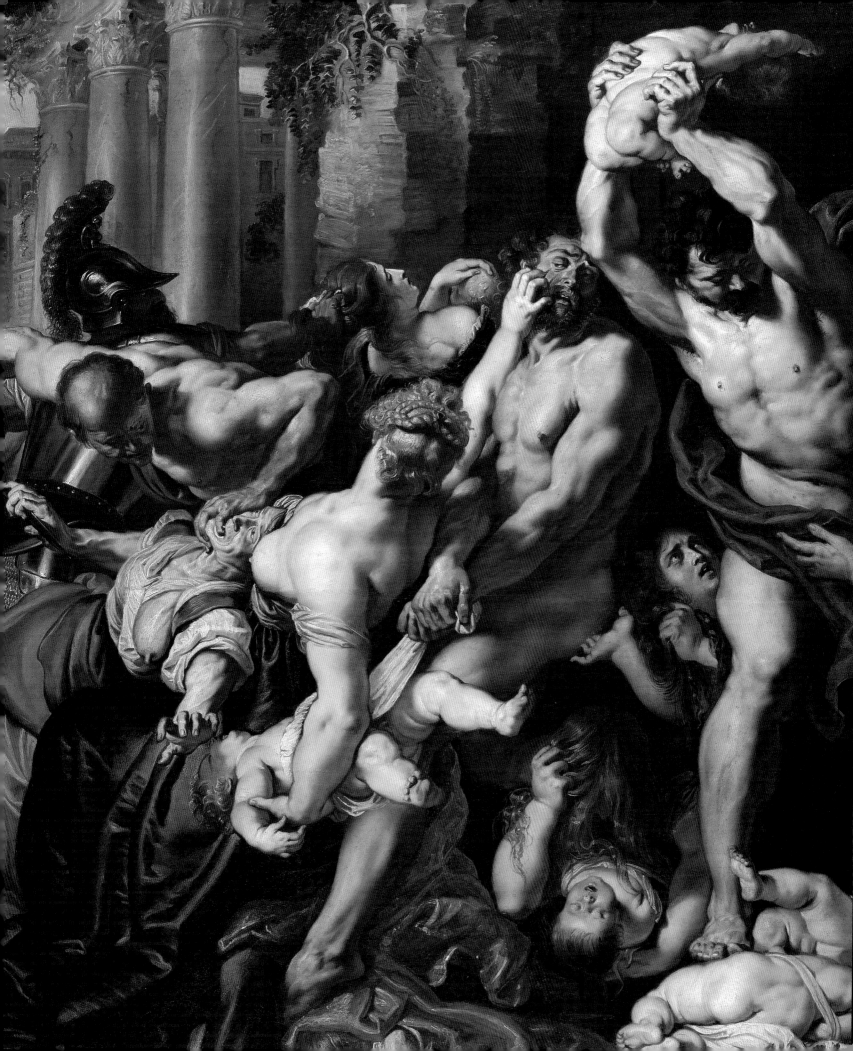

from courtly restraint, those twisting fingers – the picture is of a particular person in an obviously particular role about which every detail asks us to speculate. Ken laughed in anticipation and the deal was soon done.

Ken's tastes, by the time we became friends, towards the end of his life, had a long history. He first came across Rubens in the Liechenstein collections as a young man on a visit to Kraus Thomson in that tiny state. But only later had he developed enough of a liking to buy a group of the master's drawings when they appeared at Christie's, London, in 1987 (fig. 23). And the purchase of a major work from this extravagantly gifted painter came after long consideration.

Rubens's *Massacre of the Innocents* (fig. 18) is altogether extraordinary. When bought in 2002 for £49.5 million it was the costliest painting ever to have graced the premises of an international auction house. To my surprise its authenticity was immediately questioned in the London press, and an exhaustive review of the case for and against began. I conducted the review, with help from the London National Gallery's Rubens scholar David Jaffé, and reported frequently and at length to Ken. On this occasion Ken was certainly caught up in the cut and thrust of the debate and well able to evaluate the evidence. It transpired that the questioners were unable to follow the arguments of the chemist and the dendrochronologist whom the auction house had brought in to support their attribution, and questioning eventually ceased. At each stage of the investigation Ken's interest was focused on the concepts and the expressive devices of the artist, be he who he may be. In short, it was the nature of the task under-taken, the sorts of feeling brought to it, and the effectiveness of the solutions found for formal and expressive problems which mattered most.

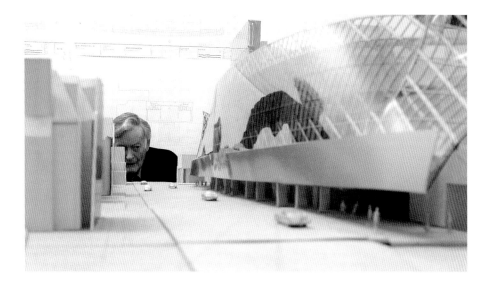

21
Ken Thomson studying
Frank Gehry's model of
the new extension of the
Art Gallery of Ontario

22
A view of the Art Gallery of
Ontario taken just before
re-opening in November 2008,
looking down Dundas Street

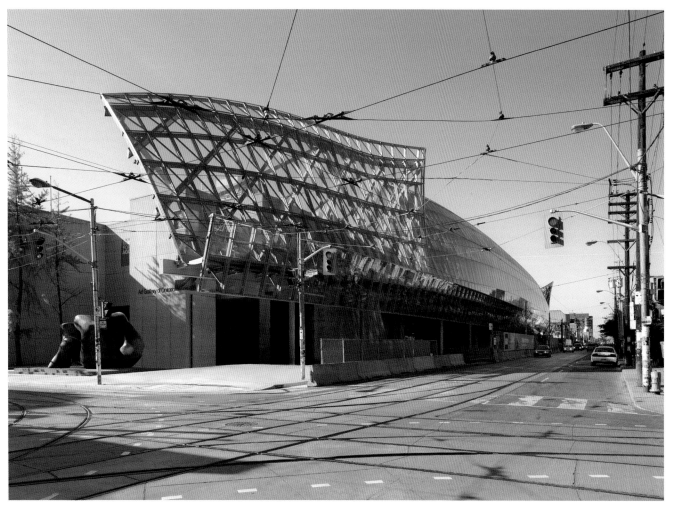

23
PETER PAUL RUBENS
(1577–1640)
**Anatomical study of a nude
striding to the right**
1606–08
Black chalk, pen and brown ink
28.8 × 18.8 cm

**THE
HUMBLE
PATRON**

In his own words, Canada's richest man talks about his gift to the Art Gallery of Ontario

Ken did want assurance that this was the genuine article but the debate about authorship could finally be justified because it led to an increase in the tangibility of a work of art.

I twice had an opportunity to discuss the *Massacre* with Ken as, on loan to the London National Gallery, it hung in front of us. He was intrigued by the dilemma facing Rubens, who had to treat a subject of surpassing horror, the murder of children, and yet leave his spectators mentally exercised and in a state of spiritual elevation. Ken was visibly fascinated when he understood how Rubens's sheer virtuosity, his extravagant display of anatomical learning, the omnicompetence of his draftsmanship, and the ingenuity of a compositional scheme which not only led the eye an exhilarating dance but somehow let a sense of heroic maternity surface from the mêlée met every expectation.

Ken, I may say, was aghast at the cost of the *Massacre*. It was always gratifying to him that he could extract meaning from small and often relatively inexpensive objects, which tended to be neglected by the high culture crowd. He never forgot his father's modest beginnings and may have distrusted his own prosperity. Far from indulging his liking and his need for art, he kept a tight rein on purchasing and, I suspect, felt a degree of guilt when impelled to make a big buy. His last words on a picture to which he was drawn, Canaletto's *New London Bridge,* were, "You can't have everything you want."

Over and above his patriotism it was, I believe, a wish to share the excitement of discovery and the profound satisfaction, the pervasive serenity, which engagement with works of art brought him that led Ken Thomson to present the bulk of his collection to the Art Gallery of Ontario, together with funding for its maintenance and for the huge enlargement of the building which Frank Gehry has designed (figs. 21, 22). Association with people he found utterly sympathetic was an important, I should say vital, dimension of collecting to Ken. Friendship with Gehry was a late but much valued feature of Ken's last years and it is my guess that the Gehry team has never been so determined to reflect in a building's structure the nature of its contents: these contents in turn embody so much of Ken's own nature that the *tout ensemble* will inevitably speak insistently to all who knew him of the man's intelligence and sensibility.

Letters

When composing my overview of Ken Thomson the collector I was able (by kind permission of the present head of the family) to examine his correspondence with dealers. This allowed me to cross-check, and helped me to substantiate, my own impressions of the man. It was, I must say, a moving experience. Ken wrote pretty much as he spoke: the tone of his conversation and even the sound of his voice arise ineluctably from the page.

The following group of letters, from and to Ken, shows in the clearest fashion the intensity of his involvement with the things he collected, and documents the sheer pleasure which the business of collecting gave him. Some of those with whom Ken was associated on the trail of works which might come to hold special meanings for him, the often lengthy and complex process of identification and acquisition, became friends, and a few of these were amongst the most valued members of his circle.

Hermann Baer was the first real mentor in Ken's collecting career and his enthusiasm no less than his expertise had a lifelong effect. The letters reproduced here are touching evidence of the affection each felt for the other.

Hermann Baer

THOMSON OF FLEET

65 Queen Street West, Toronto, Ontario, M5H 2M8, Canada

October 14, 1998

Ms. Eva M. Weininger
Antiquarian Books
79 Greenhill
Prince Arthur Road
London NW3 5TZ
England

Dear Eva,

I would ask you to please be understanding and forgive what might seem like a commercial, and even selfish, note regarding Maria's passing.

You will realize that Hermann and I had a very special relationship. I have had a handful of happy and fortunate relationships in my business and collecting career, but none to equal the warmth and closeness of that between Hermann and myself, and my family.

Hermann had a number of art treasures that he loved dearly. He could not bear to part with them in his lifetime but I know that Hermann wanted me to have them join the collection after his passing.

Maria chose to keep most of them and, I am convinced, did so primarily in what she perceived to be the best interests of the family.

There were several objects of particular sentimental value to me. The prime one was a boxwood, ivory and mother-of-pearl tailor's rule. If Maria kept this – and I pray that she did – I would love to have the opportunity of acquiring it. If you can protect me in this, wherever it is presently or however it might be disposed of in future, I would be grateful beyond words, Eva.

There were other small but not necessarily fabulous objects – for instance a 17th or 18th century ivory cup with a hunting scene and a silver-gilt rim.

24
South Germany
(1600–09)
Tailor's yard with animal imagery
Fruitwood and ivory
Length 54 cm

And what has become of Hermann's desk, which he used to use in his Davies Street shop? Hermann used to pull objects and photographs out of it like a magician! This desk would have a very special meaning for me. Maria used to have it on a ledge a few steps off the living room area, next to a window if I recall correctly. Anyway, there is only one desk. It was of oak, I believe.

Of course all this may be academic, as Maria may have handled everything very specifically in her will.

If you can give me any information relative to the above I will be truly grateful to you, Eva.

Again, please understand and forgive my very direct approach, but I would not be able to forgive myself if I were to lose out by default on something that means so much to me personally.

With kindest regards,

Yours sincerely,

THOMSON OF FLEET

Thomson Works of Art Limited

65 Queen Street West Tel 416 364-8700 **Thomson of Fleet**
Suite 2400 Fax 416 367-3549 President
Toronto, Ontario kthomson@woodbridge.com
Canada M5H 2M8

Thomson

February 25, 2005

Sir Ronald Grierson
5-7 Carlton Gardens
London, SW1Y 5AD
ENGLAND

Dear Ronnie:

Something extraordinary happened to me yesterday at the Sotheby's sale of the Adler collection. My hunch may be completely off base but I fear that once again I might have unwittingly done battle with the Prince of Liechtenstein. I am referring to the sale of the tailor's yard, lot 85, at the incredible hammer price of £120,000. For reasons I explain below I was the one who made the successful bid. That was painful enough but it would be even more painful if the Prince also had coveted it and yet again we bid against one another. If this happened, I am truly sorry. I derive no satisfaction from winning such a bidding match against the Prince.

Whether or not the Prince was the underbidder, a bit of background might be interesting to you.

Hermann Baer was a wonderful old German art dealer who was driven out of Germany by Hitler in the 1930s. He established himself in London. With no capital but with total integrity he ended up being one of most respected dealers in the art world. I met Hermann in 1959 and from the moment we met we got along like house afire. Early in our relationship I visited his home where he showed me what he referred to as his tailor's rule (Sotheby's call it a tailor's yard). He loved it and I immediately loved it too. It came to symbolize the relationship between us. Hermann used to say, "Don't worry, Ken, the name is Thomson." That meant that I was to get it after he passed away, but sadly that did not happen. The woman (his secretary), whom he married a couple of weeks before he died, was instructed by Hermann to let me have it and several other fine objects at prices he specified. Some of them came to me but others did not, including the tailor's rule. The gentleman who got the tailor's rule out of Maria kept it in his collection until yesterday, when his entire collection was sold at Sotheby's.

.../2

40

Sir Ronald Grierson
February 25, 2005
Page 2.

When bidding on the tailor's rule started to get ridiculous I felt I had to keep going even though I knew the price was getting totally out of hand. I could not let all those memories between Hermann and myself disappear. For the rest of my life I would have regretted that tailor's rule being anywhere other than in my possession. I never like to pay hugely over what I feel an object is worth, but I felt I had to in this case because my heart was involved.

If the Prince was indeed the underbidder, please tell him I am sorry and feel free to pass these facts on to him. Fascinating for me to recall my meeting him when he was a young man. Little did I realize what a tremendous contribution he would make to the art world. I really do admire him very much and wish him the best as he continues to make such a wonderful contribution to posterity.

Of course it may not have been the Prince who was bidding against me, in which case I hope you will still find this letter of interest.

Isn't the art world a fascinating one, Ronnie?

Trust all goes well.

Yours sincerely,

The Romanesque ivory chessman

For Ken, the thrill of the chase was a vital part of collecting. A series of exchanges with Hermann Baer about the pursuit and eventual capture of a Romanesque ivory chessman (fig. 26) conveys a great deal of the excitement which could be engendered as desire was fixed on an object. In these texts, and perhaps still more clearly between the lines, a characteristic mix of mounting interest and the pleasurable anticipation of success in the saleroom with a not so pleasurable anxiety is apparent. The achievement of what had soon become an important goal produced something like ecstasy.

Tuesday 25 *April 27th,* 1965

37 AN IMPORTANT ROMANESQUE MORSE IVORY CHESSMAN, showing a king crowned and robed seated upon a throne, and holding in his hands a covered pyx, beneath a semi-circular arch, the spandrels with wings of eagles which rest upon the capitals of hexagonal columns terminating in moulded bases, the sides also arcaded with a figure of a soldier with a long heater-shaped shield with pronounced umbo, on the right hand side, balanced by a figure of a soldier holding a sword on the other, the tiled roof with a moulded frieze and battlemented border, *3in., Cologne, end of 12th Century*

** Exhibited in the Burlington Fine Arts Club Exhibition of Ivories, 1923, no. 86.

Illustrated by Goldschmidt, *Die Elfenbeinskulpturen aus der Zeit der Karolingischen und Sächsischen Kaiser*, vol. IV, p. 274.

[*See* ILLUSTRATION]

Hermann Baer · *Interior Decorator & Art Dealer* · **6 Davies Street W1** · *Telephone Mayfair 7370 & 3757*

10th March 1965.

Ken R. Thomson, Esq.
425, University Avenue
Toronto.

Dear Ken,

I spent this morning at Sotheby's behind the scenes.
There is a little bit of Art News to occupy yourself over
the weekend. It's about the same sale and the same property
as the Limoges panel of the St. Anne and the enamel plaque
of which I sent you already a photo.

The ivory Chessman, which I studied very carefully to-
day, is absolutely sensational. -*RARE, RARE.*

The Spanish ivory plaquette is very rare.

The Chasse is absolutely wonderful in every respect.
I try to get you one day a colour plate.

The 2 Marchands will be sold on the 26th March. Two ca-
talogues are enclosed. We ought to get them anywhere between
£ 600 and £ 1000.-.-.

The chess stone might fetch anything between £ 1000.-.-
and £ 4000.-.-, one just can't tell.

Yours sincerely,

Hermann

12th March, 1965.

Mr. H. Baer,
6 Davies Street,
LONDON, W.1.

Dear Hermann,

I was interested to receive your letter of March 10th together with the two illustrated catalogues of Sotheby's Sale of March 26th.

1. The Le Marchand busts.

I note that Sotheby's have made a definite attribution to Le Marchand and, judging by the photographs, I would endorse this completely.

I note that these busts are on turned wood socles and I am assuming that they have been added at another period and are of no account. If they are not proper I will probably have them removed. You will note I am talking as if they were mine already. I am considering that they virtually are as I don't want them to slip by us.

Note the reference to the ivory relief of Newton which we bought in 1963.

I note that they expect between £600 and £1,000 for the Le Marchands and we should certainly be prepared to meet any price within this range - indeed use your judgement as to how high we should go if necessary.

2. <u>The 12th century ivory Chessman.</u>

This looks extremely interesting and fine.
The photograph makes it look highly desirable.
I note your reference to the fact that it is
absolutely sensational and extremely rare.
No doubt I will hear further from you on this
particular object. Meanwhile, I am certain
that this one will hold our serious interest.

I note that this object is very unpredictable
regarding the price it might fetch, the possible
range being anywhere from £1,000 to £4,000. I
think we should save some of our firepower for
this particular object.

3. <u>The Spanish ivory plaquette.</u>

This looks interesting but, admittedly, it is
not overly attractive. The first impression seems
to be that this object is interesting because of
its rarity and its historical importance rather
than its beauty. However, regarding its antiquity
(12th century) this is understandable, although in
attractiveness the Chessman certainly supersedes it
in my opinion.

I gather that this object is coming up for sale
on April 27th so we will have lots of opportunity to
consider it before then.

4. <u>12th century Limoge Enamel Chase.</u>

At first glance this was not overly thrilling
but I read the information and noted the delicate
size (only 8-3/4 ins. long). Perhaps when seen
in colour it would be highly attractive; indeed it
would appear to be so according to your own
enthusiasm. If you do manage to have a coloured
photograph taken might I suggest that it show the
object actual size. The black and white photograph
will do for detail.

I note that this object is to come up on April
27th, which again gives us time to consider it
thoroughly. At this moment, however, I assume we
will probably have a serious interest in it.

I have noted the information regarding the gold and
enamel plaque.

I shall take all this information home and study it
carefully.

Yours sincerely,

K.R. Thomson:em

Hermann Baer

Hermann Baer · *Interior Decorator & Art Dealer* · **6 Davies Street W1** · *Telephone Mayfair 7370 & 3757*

16th March 1965.

Ken R. Thomson, Esq.
425, University Avenue
Toronto.

Dear Ken,

The Cheverton is here on my desk and I think, it is
very attractive. He would not let it go under £ 90.-.-
under any circumstances, and although his man had asked
me £ 90.-.- a few days ago, Marcussen himself asked me
£ 95.-.-, as it cost him £ 85.-.-, but eventually he let
me have it for £ 90.-.-. I think, you will be very happy,
it's the most attractive bust - photo to follow.

The St. Anne Limoges chapter seems to be closed.

I confused you with my letter of March 10th. The illust-
ration refers, of course, to the Gothic ivory dyptich,
which we bought at Sotheby's.

Just for your general information: I visit practically
every week all dealers, where there is the slightest poss-
ibility to find something for us - apart from all London
salesrooms.

I find the Marchand busts so attractive, that I am
going to buy them, if not one of the Museums interferes
unpredictably.

I am very satisfied, that you share my feeling about
the ivory Chessman. We must get it. This is a unique chance,
which might never come again, and I am absolutely sure, that
we have to face opposition from some of the greatest Museums
of the World. F

I have looked at the Spanish ivory plaquette several
times again, and it appeals to me more every time I look
at it. It's still not Spanish for me.

I try to get you a coloured illustration of the enamel
Chase, but in any case you will get one in good time, because
it's illustrated in colour in the catalogue.

We seem to have passed the Wintersleep.

Yours very sincerely,

[signature]

F I am sure to nearer 4000 than 1000

46

5th April, 1965.

Mr. H. Baer,
6 Davies Street,
LONDON, W.1.

Dear Hermann,

I have received Sotheby's illustrated catalogue
of the Stoclet sale on April 27th. Some of the
objects illustrated certainly make the mouth water.

I would like to comment specifically on the
following :

Lots 33 and 34. - The Gold Clasp and the Gold Cross.
These remain extremely attractive and desirable in my
eyes and they certainly warrant our serious consideration.
I have a feeling that we are already in agreement as to
their desirability. The big factor is the price
involved. I feel it might be considerable. When
you can give me any idea please let me know what the
cost might involve.

Lot 36 - A Romanesque Ivory Plaque. We have not
discussed this ivory - perhaps because you don't want to recommend
it. Frankly, it is a little crude, but this was, at one
time, my feeling about Gothic ivories and my views have
changed over the years. If, by chance, this particular
ivory is extremely important and desirable as an example
of this style and period then I would welcome your
personal views as to whether it would make a worthwhile
addition to the collection, particularly anticipating
the fact that the collection is broadening all the time.

Lot 37 - The Ivory Chessman. Again, I think we
are in agreement about this object and the fact that it
must come our way if possible. The only factor which
could upset us would be the price. I would appreciate
your discussing the cost factor with me as the sale
date approaches so that we can decide approximately
how far we want to go and how far we might have to go.

Lot 41 - Copper-gilt figure of Christ Crucified.
It is difficult to visualise exactly what this will look
like "in the flesh". Judging from the photograph it is,
in any event, interesting. What do you think of it?
How desirable is it and, if it is worth considering
seriously, what price might be involved?

Lot 42 - Early Limoges Champleve Crucifix. This,
too, is somewhat different from anything we have
interested ourselves in to date, but it certainly looks
attractive. I should think it is likely to be quite
valuable. Again, I would like your views on this one.

Lot 45 - Limoges Chanpleve Enamel Chasse. This
does indeed look superb. Again, its desirability
would appear to be beyond discussion. The anticipated
price is, I believe, extremely high. Once more, please
let me have your further thoughts and prediction as to
price as the sale approaches.

Lot 51 - Byzantine Gold Necklace. This is not
strictly sculptural but yet it borders upon it.
In any event this necklace looks quite interesting.
I wonder what you think of it?

Lot 52 - Rare Spanish Romanesque Ivory Plaque.
Again, this object certainly doesn't appear to be overly
attractive to me. It may well be rare as the catalogue
states and as you apparently confirm, but unless you
are extremely enthusiastic about it I would not look
forward to bidding seriously on it.

Lot 53 - Gold Book Cover. This, on the other hand,
judging by the black and white illustration, could be
interesting. I wonder what you think of it? Again,
what kind of money could be involved?

Lot 56 - Fine Limoges Champleve Enamel Crozier.
Do you have any feeling for this work? It seems to me
that this is the kind of thing you would enthuse about
if its quality was up to standard.

I have noted the coloured illustration on the
frontispiece of the Byzantine Mosaic Icon. It is
most attractive but I should imagine it will probably
fetch quite a price, will it not?

This sale will be very interesting. My big fear is the
prices that could be involved. Nevertheless, I don't want
to lose an opportunity to acquire objects which, in the future,
could not be duplicated.

Yours sincerely,

9th April, 1965.

Mr. H. Baer,
6 Davies Street,
LONDON, W.1.

Dear Hermann,

Your letter of April 7th regarding the Stoclet
sale warrants a separate letter, particularly in view
of our conversation over the telephone this morning.

Our thinking in this matter is exactly alike.
Since writing to you at the beginning of the week I,
too, had come to the conclusion that our main interests
lie in the gold clasp and cross, Lots 33 and 34,
the ivory Chessman, Lot 37, and the Chasse, Lot 45.
I gather that nothing else in the sale really interests
us seriously and this is not a surprise to me.

I have noted the prices which the above objects
might fetch under the hammer and I agree with you that
we should have a serious go at the cross and the clasp and
the ivory Chessman. I realise that if the bidding is
extremely heavy, particularly from a source such as
the Metropolitan Museum, some or all of these objects
might escape us, in which case I think we should have
a really good try for the Chasse. I would, however,
prefer to be successful with the cross and clasp, and
the Chessman, and the Chasse we could let go by. This
is our thinking at the moment, but we have lots of time
to reconfirm.

2.

I was interested to hear that the gold book cover,
in your considered judgment, is not right. It does
look somewhat flat from the photograph but if anything
of this nature turns up in future we should have a
special interest in it as I like this type of object
and some of them can be extremely beautiful.

It was nice to speak with you again.

All the best.

Yours sincerely,

K.R. Thomson:em

Hermann Baer

Hermann Baer · *Interior Decorator & Art Dealer* · **6 Davies Street W1** · *Telephone Mayfair 7370 & 3757*

12th April 1965.

Ken R. Thomson, Esq.
425, University Avenue
Toronto.

Dear Ken,

there is no doubt about it, we will face a formidable opposition on the 27th. I went this morning again to Sotheby's to study all the objects in question a bit more.

Several objects were not available, especially lots 33 and 34, also 21. They are for the moment in the British Museum to be considered by the Trustees.

By pure chance I heard, that Mr. Kofler-Turniger, the Collector from Lucerne, has booked a room at the Ritz from the 25th to 28th April. He will be a formidable opponent, mainly, I would say, for 34 and definitely for No. 37. But all those circumstances should not influence us too much. There is a limit for everything, and I think, we must act accordingly.

If we don't get anything, we still go on collecting, and there are quite a number of objects in my possession, which Mr. Kofler wants very badly and will certainly not get.

Yours very sincerely,

Hermann

P.S.: But one thing we ought to make sure, whoever buys
 lot 33, 34, 37 against us, should pay for it. And
 if we fall through with lot 33, 34, 37, we ought to
 fight for Lot 45 to the limit.

12th April, 1965.

Mr. H. Baer,
6 Davies Street,
LONDON, W.1.

Dear Hermann,

I have received your letter of April 9th with
your numerous comments regarding the Stoclet sale.
Most of these matters have already been covered, but
I should like to make one or two comments on the
points you bring up.

Lot 36. I am neither surprised nor disappointed
that you are not keen on this object - neither am I.

Lot 41. Following your comments, my interest
in this has been killed out.

Lot 42. In view of the damage, the price that
might be involved, and the nature of the object, I
have no further interest in it.

Lot 51. I entirely agree with your comments
that, although this is attractive in its own way, we
should save our fire power for other objects.

Lot 52. There is no doubt about this one.
It is out.

Lot 53. Again, this is dead.

Lot 54. Likewise.

Regarding the Mosaic Icon, this certainly is not our cup of tea.

I have thought further about this sale over the weekend and I have come to a definite conclusion which I hope won't disappoint you. I think we should concentrate all our fire power on Lots 33 and 34, the Gold Cross and the Gold Clasp, and Lot 37, the ivory Chessman. In my eyes these are by far the most attractive and desirable objects in the whole collection, more so to me than the Chasse. I feel, therefore, that beautiful as the Chasse is we should let it go by because it will obviously fetch a tremendous price. When £15,000 to £25,000 is involved the object must be of such desirability that I have to have it. I really cannot say this is the case with the Chasse although I realise it must be magnificent in its own way. Why not, therefore, concentrate entirely on the three above-mentioned objects and hope for the best.

If I were to lose out on Lots 33, 34 and 37 it would be little compensation for me to obtain the Chasse at a very high price. It would, despite the money involved, be an anti-climax . In view of this feeling I think you will agree with me that we should limit ourselves to the three lots.

I shall be interested to have your reaction to this suggestion.

Thank you for obtaining for me the six illustrated catalogues and also for enclosing the two receipts.

Kind personal regards.

Yours sincerely,

K.R. Thomson:em

14th April, 1965.

Mr. H. Baer,
6 Davies Street,
LONDON, W.1.

Dear Hermann,

Thank you for your letter of April 12th.

In face of your comments, I am certain that the
bidding will be extremely heavy on April 27th. If
the British Museum is interested in Lots 33 and 34
this alone should make the prices sky-rocket, much
less additional possible opposition from other Museums.

I note further that Mr. Kofler-Turniger of Lucerne
has booked a room at the Ritz during the sale period,
which makes it virtually certain that he will be
competition for us, and I note you predict definitely
in the case of Lots 34 and 37. Actually, these are
the two lots that interest me the most. Lot 34 has
a slight edge, in my eyes, over Lot 33. If I were to
succeed in acquiring two lots from this collection
I would want them to be Lots 34 and 37, with Lot 33
just a step behind. Indeed, if Lot 33 fetches a very
high price, higher than we wish to pay, then it might
be an idea to let Lot 33 pass and shoot the works on
Lots 34 and 37. If Lot 34 escapes us then surely
we can go after Lot 37 even harder. This way I feel
we might have a chance on Lots 34 and/or 37. If the
sale were to take place tomorrow this would be my
feeling but we must discuss it once more at least
before the sale to finalise our thinking.

I still feel basically as I did on Monday when
I last wrote you that we should concentrate all our
fire-power on Lots 33, 34 and 37 and, if we have to
narrow it further, to Lots 34 and 37.

I note from your letter of April 12th that you
still feel that, if Lots 33, 34 and 37 escape us, we
should bid on Lot #45 to the limit. I shall discuss
this with you further, possibly over the telephone,
before the sale, but I am inclined to encourage you
to go all out on my first three choices and, if
necessary, on my first two choices.

The tone of your letter indicates a little
apprehension about our obtaining anything in this
sale, at least it indicates a possibility that we
might lose out on all lots. I shall, therefore, be
prepared for the worst, but I am still hoping that the
two or three lots mentioned about may come our way.

In any event, the photograph of the little ivory
St. George and the Dragon certainly raises my spirits,
regardless of the outcome of the sale. This is a truly
magnificent little sculpture. It will certainly be
the most prized possession in my collection one day.
I might say that at one time I was quite anxious to
obtain it from you but I feel quite the opposite now.
I would prefer that it remain in your possession during
your lifetime and I certainly hope that it does so
for a long time to come.

All the best.

Yours sincerely,

K.R. Thomson:em

26th April, 1965.

Mr. H. Baer,
6 Davies Street,
LONDON, W.1.

Dear Hermann,

Perhaps by now you will have seen the April 3rd
edition of the Illustrated London News containing
the article on the Stoclet sale being held tomorrow.

In particular, I was interested to note the
large illustration of the ivory Chessman and the
Chasse. They have certainly gone all out in their
illustration of the Chasse.

If we have any success in tomorrow's sale I
intend to buy several editions of this magazine.

Yours sincerely,

K.R. Thomson"em

27th April, 1965.

Mr. H. Baer,
6 Davies Street,
LONDON, W.1.

Dear Hermann,

I am sorry I was not able to take your telephone
call when it came in but I was attending the newspaper
meetings at the Hotel. At the first opportunity I
telephoned my secretary and she gave me a full report
of your telephone conversation.

I was thrilled to learn that you got the Chessman
for £10,000. I was hoping that we would get this Lot.
I was more or less resigned to the fact that Lots 33
and 34 would escape us.

My secretary told me that you did not bid on the
Chessman until around the £8,000 mark. I shall be
most interested to hear all the details of the bidding
and who the under-bidders were. Did Mr. Kofler-Turniger
bid directly? I wonder how far he went?

Lots 33 and 34 apparently fetched £6,500 and £8,500
respectively. They must have been very beautiful
and it would be sour grapes to detract from them in
any way, but, in view of the prices involved and the
tremendous compensation of our getting the Chessman,
which was our first choice, I am not at all upset
about losing out on Lots 33 and 34. As I explained
to you, my philosophy is that you can't have everything.

2.

I was interested to hear that the Chasse and the
Mosan Champleve Enamel plaque fetched £32,000 and £35,000
respectively. These are staggerin prices for such small
objects. Undoubtedly they were unique in the world and
of extreme importance.

The main thing is that we are completely happy and
satisfied with the results of the sale.

No doubt you will already have in hand the matter
of illustrated catalogues, newspaper cuttings, etc.
and I was pleased to hear that the Chasse has already
been placed in the safely deposit box.

Once again, many thanks. It has certainly been
a Red Letter Day.

Kind personal regards.

Yours sincerely,

K.R. Thomson:em

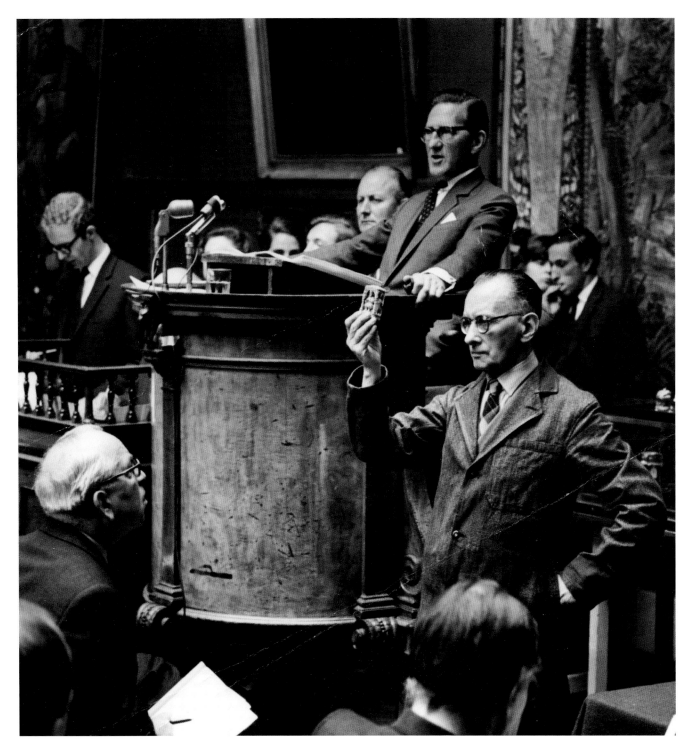

25
Sotheby's, London, April 27, 1965:
final bid for the Romanesque chessman

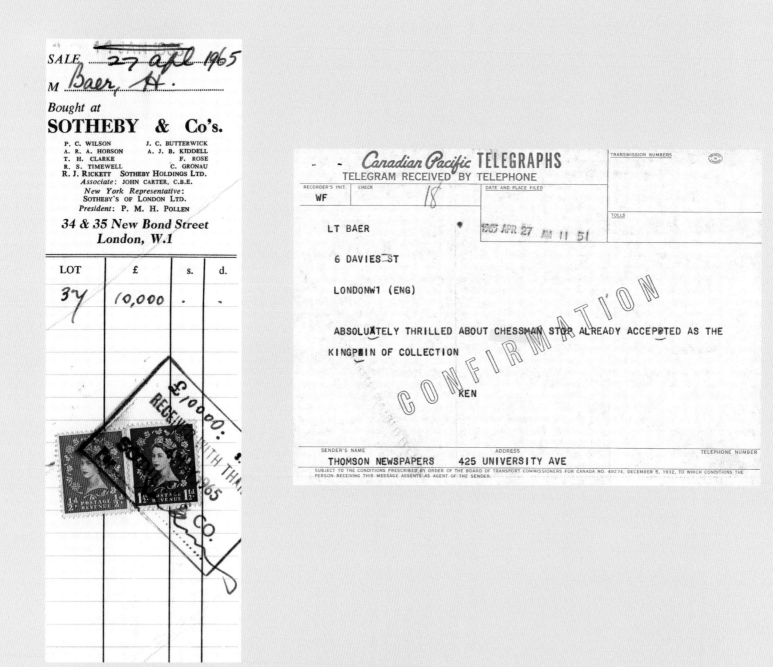

SALE 27 apl 1965
M Baer, H.

Bought at

SOTHEBY & Co's.

P. C. WILSON J. C. BUTTERWICK
A. R. A. HOBSON A. J. B. KIDDELL
T. H. CLARKE F. ROSE
R. S. TIMEWELL C. GRONAU
R. J. RICKETT SOTHEBY HOLDINGS LTD.
Associate: JOHN CARTER, C.B.E.
New York Representative:
SOTHEBY'S OF LONDON LTD.
President: P. M. H. POLLEN

34 & 35 New Bond Street
London, W.1

LOT	£	s.	d.
37	10,000	-	-

Canadian Pacific **TELEGRAPHS**
TELEGRAM RECEIVED BY TELEPHONE

TRANSMISSION NUMBERS

RECORDER'S INIT. CHECK

WF 18

DATE AND PLACE FILED

1965 APR 27 AM 11 51

TOLLS

LT BAER

6 DAVIES ST

LONDONW1 (ENG)

ABSOLUTELY THRILLED ABOUT CHESSMAN STOP ALREADY ACCEPTED AS THE

KINGPIN OF COLLECTION

KEN

SENDER'S NAME ADDRESS TELEPHONE NUMBER

THOMSON NEWSPAPERS 425 UNIVERSITY AVE

SUBJECT TO THE CONDITIONS PRESCRIBED BY ORDER OF THE BOARD OF TRANSPORT COMMISSIONERS FOR CANADA NO. 49274, DECEMBER 5, 1932, TO WHICH CONDITIONS THE
PERSON RECEIVING THIS MESSAGE ASSENTS AS AGENT OF THE SENDER.

Hermann Baer

Hermann Baer · *Interior Decorator & Art Dealer* · **6 Davies Street W1** · *Telephone Mayfair 7370 & 3757*

28th April 1965.

Ken R. Thomson, Esq.
425, University Avenue
Toronto.

Dear Ken,

Jim Clarke of Sotheby's just suggested to have the chessman photographed again for the Yearbook. I find the photographs horribly bad in comparison to the real object. I agreed, but I told him, this could only be done under my supervision, because I shall not let the object out of my hands again - it will either be in my pocket or in the safe No. 530 in the Bank of America.

I had more congratulation with reference to the chessman than I had to my 50th birthday.

Two tear sheets of the Financial Times which mentions the chessman will be kept here and be sent to you with the next parcel.

Yours sincerely,

Hermann

Absolutely thrilled

as you expressed your feelings in a telegram which just arrived —

That's exactly how I feel the last 24 Hours

59

28th April, 1965.

Dear Harry,

In the very strictest confidence I would advise
you that yesterday I took the biggest step I have
ever taken in building up my collection of small
sculpture.

You will have possibly noted in the paper that
a 12th century ivory Chessman was purchased at Sotheby's
for £10,000. Hermann Baer bought this for me. He
probably bid on it anonymously, although there is a
possibility that he is known to be the purchaser of this
lot. In any event, no one will be told that he
purchased it on my behalf.

During the past two years or so my collection has
reached the very top level as will be evidenced by this
recent acquisition. I simply cannot go any higher in
the stature of the objects I am collecting. This,
of course, changes my position as a collector and,
indeed, changes my collection considerably. It has
its advantages and disadvantages but, of course, the
advantages far outweigh the disadvantages. One slight
deficit is that, in future, it will be most unlikely
that I will ever come upon objects suitable for my
collection by browsing through antique shops. The odd
Cheverton may come my way but already I regard my
Cheverton collection as outside the main body of my
collecting. Also, in future, I will undoubtedly be
turning back certain objects which I acquired in the
early years. The main thing is that I am now collecting
on the highest level and that as my collection grows
it will surely become one of the finest in private hands.

2.

I wanted you to know this as my early interest in
antiquities goes back to the days when we first met.

Kind personal regards.

Yours sincerely,

K.R. Thomson:em

29th April, 1965.

Mr. H. Baer,
6 Davies Street,
LONDON, W.1.

Dear Hermann,

Thank you for your letter of April 27th.

I was interested to have further details of
the bidding at the Stoclet sale. Particularly
interesting was the fact that Kofler purchased
Lot 45, the Chasse, for £32,000. I presume that
he saved his fire power for this one Lot. I am
pleased he did so as I much prefer the Chessman
over the Chasse, although it must be colourful and
beautiful.

I can imagine that there has been considerable
Museum interest in the Chessman, as is evidenced by
the visit of Mr. Rorimer of the Metropolitan Museum
in New York.

My breath is still somewhat taken away by the
price involved, but I know it was a sound purchase
and it is certainly one that pleases me and adds
tremendously to my collection.

I am today writing Mr. Charles requesting that
he send you a cheque for £10,000 made payable to
Sotheby & Co. as soon as possible.

I have been wondering whether it might be an idea to have a tiny case made for the Chessman. What I had in mind was a two-tier velvet covered platform with the sides covered with glass. The feet and the shape and decoration of the top of the case would have to be appropriate. What I seem to have in my mind is a Gothic design, but I realise that the period of the ivory is earlier. I think the Chessman is so important that it should be encased completely, even inside a cabinet. I would like you to give a little thought as to how this could be achieved. If you can put any of your ideas on paper I would appreciate a little sketch. This is a matter for your leisure.

I have already ordered ten copies of the April 3rd edition of the Illustrated London News.

I was very interested in Mr. Rorimer's reference to the boxwood Madonna and was pleased to examine the photograph you sent me. This is one of my favourites. This Madonna and the little ivory St. George were two of the first objects which you showed me. My enthusiasm for them has not diminished one whit in the meantime. I can understand why Mr. Rorimer would like to have the Madonna for the Metropolitan Museum one day and I am delighted to know that it will join my collection. At that time I hope it is in very good company.

Kind personal regards.

Yours sincerely,

K.R. Thomson:em

Hermann Baer

Hermann Baer · *Interior Decorator & Art Dealer* · **6 Davies Street W1** · *Telephone Mayfair 7370 & 3757*

30th April 1965.

Ken R. Thomson, Esq.
425, University Avenue
Toronto.

Dear Ken,

what makes our success double exciting, is, that it is
a Chessman - a worldly object, from a game. 99% of all Art
in the Middle Ages consisted of religious subjects inspired
by the power of the Church, which was the centre of all.

Ken, you might buy many objects in your life - objects
of greater value, of greater importance, but remember always,
that you will never get a more magnificent, pure and noble
object from the Middle Ages.

I want to make it absolutely clear to you, what it
means to me. What I felt immediately, when I saw it for the
first time, I expressed to you in my first letters (March 10th
and 16th). Here in London in Arts Circles it is only now felt.
I prefer it to any Byzantine object. Byzantine Art at about
the year 1000 was actually a dying art then, coming from the
old civilisation. All the Byzantine Architecture, Sculpture,
Paintings were influenced by the Classic, Greek & Roman per-
iods. I like the chessman so much, because it is the product
of the new spirit in the Middle Ages, which from about 1100
onwards influences everything: Art, Music, Literature and so on.
It makes itself independent from the Byzantine influence, from
the classical heritage. It expresses a more Western national
spirit. It creates the style, which eventually goes over into
the noble character of the Gothic.

Never, dear Ken, part from this object - except if you
have to exchange it for bread and salt for your wife and
children. - I get a bit emotional, but remember, to stand in
a Sales room in the heart of the World to buy this object in
the presence of so many experts, was the proudest day in my
professional life - and will always be.

This letter is written to commemorate the entry of the
Chessman - Lot 37 from Sotheby's sale of April 27th 1965 -
from the Stoclet Collection into the Ken Thomson Collection.

Yours very sincerely,

Hermann

Walrus-ivory-chess-stone from the Collection Jaques Stoclet.
Auctioned on April 17th 1965 at Sotheby's,
London for £ 10 000.-.-.

It is considered one of the rarest and noblest objects of the
Middle Ages, which appeared on the market since many years.
It originates from the third quarter of the 12th century and
was made most likely in Cologne. -
The new owner of the stone, Mr. Hermann Baer in London, thinks
that the seated figure of the King represents Frederic I., later
called Kaiser Barbarossa (Emperor Barbarossa).

This is one of the most original objects of the New period after
the end of the Byzantine period. It breathes already the new
Western National spirit, which found its most beautiful ~~complete-~~
~~ness~~ *perfection* in the Gothic.

The stone is illustrated in the main work of Goldschmidt's
"Die Elfenbeinskulpturen aus der Zeit der Karolingischen und
Saechsischen Kaiser" (The ivory sculptures from the period of
the Karolingian and Saxonian Emperors), volume IV, Page 274.

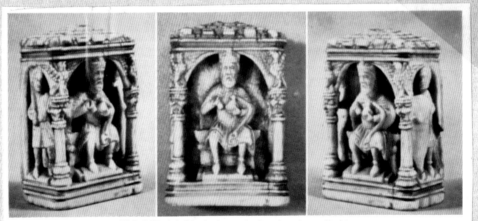

Walroß-Elfenbein-Schachstein aus der Sammlung Jaques Stoclet.
Am 17. April 1965 bei Sotheby's, London, für £ 10.000.–. versteigert.
Es dürfte eines der seltensten und edelsten Objekte des Mittelalters sein, das seit vielen Jahren auf den Markt kam. Er stammt
aus dem 3. Viertel des 12. Jahrhunderts und wurde vermutlich in Köln hergestellt.
Der neue Besitzer des Steins, Mr. Hermann Baer in London, meint, daß es sich bei dem sitzenden König um Friedrich I.
handelt, später Kaiser Barbarossa genannt. Nach dem byzantinischen Ausklang ist dies eines der ursprünglichsten Objekte aus
der neuen Periode. Es atmet bereits den neuen westlichen nationalen Geist, der dann in der Gotik seine schönste Vollendung
findet.
Im Hauptwerk von Goldschmidt „Die Elfenbeinskulpturen aus der Zeit der Karolingischen und Sächsischen Kaiser" ist der Stein
in Band IV, Seite 274, abgebildet.

Die Weltkunst / Heft 11

26
Northern France (?)
Chesspiece (king)
Late 12th century
Walrus ivory
Height 75 mm

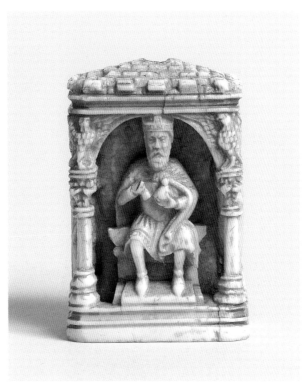

Michael Turner

Michael Turner

Michael Turner and Ken Thomson crossed paths in publishing (Michael is, *inter alia*, responsible for the English translations of the Tintin books) and soon discovered a common interest in the collecting of ship models. They found, too, that their tastes were a close match, each man revelling in fine craftsmanship and convinced that this was emotionally driven over and above the more public purposes of modelmaking. Michael, an established collector and a scholar in the field, became one of Ken's specialist advisers, and, like others of the small group whose conversation enriched Ken's constantly growing expertise and on whose judgement he believed he could rely, became a good friend. The reports with which Michael supplied Ken are altogether exemplary: they combine detailed information, succinctly organized, estimates of historical significance and pointers to the aesthetic qualities of the specimens under discussion.

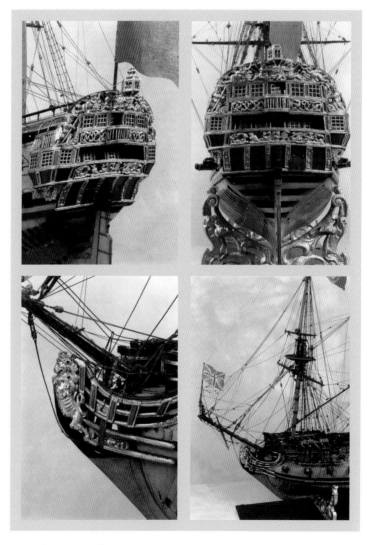

Some of the images of the *Bristol* sent to Ken Thomson by Michael Turner

26 February 1991

The Rt. Hon. Lord Thomson of Fleet
Thomson Works of Art Limited
25th Floor
65 Queen Street West
TORONTO
Ontario
Canada M5H 2M8

Dear Ken,

I am glad we were able to talk today about the Navy Board model of HMS BRISTOL that Sothebys will auction on May 22. Now that I have seen the model at Sothebys' Great West Road warehouse and been able to take preliminary photographs, I have no hesitation in saying that this is the most important Navy Board model to come on to the market since the ROYAL OAK, and while it is smaller than and not quite as decorative as that 74-gun ship - BRISTOL is pierced for 50 guns - it has its own unique features, including finely executed paintwork which is described below. For ease of relaying and appreciating the information about BRISTOL, I shall deal with the various points in numbered paragraphs.

1. BRISTOL of about 1765 - I will send full historical details later - is a 50-gun fourth-rate ship-of-the-line. At the time of its building it was already obsolete; the bulk of ships of ships-of-the-line being larger third-rates, carrying 74 guns. It succeeded a ship of the same name which was originally built in 1711, rebuilt in 1746 and broken up in 1768. BRISTOL had a distinguished career, and I believe at one point it was commanded by Nelson. There is much more historical detail to come; there has been no time yet to do any research. The fact that this was an important ship is likely to affect the price, although there are other factors that may depress it.

2. Superficially, the model is in poor condition, but it looks worse than it actually is: it is basically perfectly sound. It is fully planked (the planking is fine and of excellent colour), and at some time in the 19th century (Laurie thinks) it was rigged with rather clumsy masts and spars and supplied with sails. This rigging has been damaged and should either be removed totally or replaced. The model has obviously been stored where dust and filth could accumulate on its decks, and it has sustained damage to the figurehead, bows and head, the decking, the stern quarters and galleries. What appear to be most of the parts broken off have been put in a plastic bag, which you will see on deck in the photographs. The most serious damage is to the planking of the decks, particularly of the forecastle and the poop. It is possible that the model spent some time near

a window, and the sunlight has warped much of the planking. This will necessitate very skilled restoration. Laurie's estimate of the cost of restoration of the whole model is £10,000 upwards, but at the end of the day the model will be of the highest standard, in no way inferior to the best of the Krieghoff or National Maritime Museum models. On the question of possible rerigging, you may like to note that the National Maritime Museum has rerigged some of its models that it acquired originally as hulls.

3. There is no case, and the model is supported on rather mean wooden pillars. I don't know whether these are original, but if they are not, it is perfectly simple to replace them with something more attractive. The base-board appears at first sight to be of mahogany: it is of no particular distinction.

4. There is some excellent carving, ungilded, including a superb but damaged figurehead and allegorical figures on the stern quarters and tafferal. The balusters of the stern quarters and gallery seem to be of ivory: something to be checked. The figurehead is, I believe, of considerable importance. It is of a Roman general with the usual classical details, finely carved, with what appears to be a portrait head with a late 18th century tie-wig! The left arm of the figurehead is missing, but it may be in the plastic bag of parts that I have already mentioned. If it is really absent, then the craftsman who did the CANOPUS figurehead could be the man to produce a replacement. We shall have to find out the identity of the subject of the figurehead; it could be of some Earl of Bristol - if such a grandee actually existed! The carvings are of boxwood and their colour is lovely.

5. One of the most important features of the model is the painted decoration along the bulwarks, at the bows and head, on the stern and under the counter. The ground is dark blue and upon it are sundry fanciful allegorical figures, including gods and goddesses, mermen and mermaids, dolphins, putti and baroque foliage curlicues. It is all quite gorgeous, highly decorative, very accomplished and in very fine condition. The name of the ship is boldly displayed on below the lower row of stern windows.

6. If you decide to go for the model (and I think you will, once you have seen it and recognised its potential) we will need to think about how Laurie should be compensated for handling the acquisition and the restoration. My initial feeling is that a straight commission arrangement may not be appropriate, given that he will be essential in super-intending the restoration. It may be a bit premature to raise this point, but it may be easier to deal with it earlier than the time when we are in the hurly-burly of approaching auction. Another factor is that Laurie, in the normal course of events, would probably want to buy the model for his own business and put it into marketable shape.

I do hope that you and Marilyn will be coming to London this weekend: it will be a great help to know whether or not you will decide to make a serious try for BRISTOL. If your decision is positive, then the necessary research will not be wasted. I think it is important to remember that this is not one of the grand gilded Navy Board models of the 17th century, but these are now so excessively rare that we cannot count on one ever swimming into sight. BRISTOL is a somewhat hidden gem - we must hope that the currently depressed market will discourage many potential buyers - but with the character and underlying quality to be something really worth possessing. It doesn't have the superlative and minute French craftsmanship of CANOPUS, but in the mainstream canon of Navy Board models it is considerably more important.

As yet, I haven't seen the photographs that will accompany this letter coming to you by courier. I hope they will be adequate, but the conditions of the warehouse were hardly those of a studio and I had to use a simple flash-on-camera technique which is definitely _not_ the right way to photograph ship models.

Gordon Smith at the Quadrangle assures me that you will receive this package in Toronto by Friday afternoon, so you should have some idea of what Laurie and I have been talking about by the time we meet. I have now re-arranged my commitments, so that I will be free the whole of Tuesday, having moved my Board Meeting to Monday - one of the privileges of being Chairman of Book Trust! Laurie tells me there will be no problem in taking you to see BRISTOL at the Sothebys' warehouse - and of course there are a number of things to be seen at Kings Road.

I shall be going to Cornwall tomorrow (Wednesday) morning, and can be reached there on 011 44 8405 250 until Sunday afternoon at 4 pm my time when I aim to leave for London.

With kindest regards,

Yours sincerely,

Michael Turner

Ruth Blumka

If the taste for art was shared, and real sympathy for the spirit within certain sorts of object recognized, friendship could quickly flourish. With a speed which surprised even him, however, Ken came to feel at ease with Ruth Blumka, the New York dealer. For the extremely wealthy issues of trust are bound to bulk large, and where there is a commercial aspect an extra measure of caution must be expected: the language of the letters which follow is compelling evidence of Ken's capacity for the enjoyment of another's company once trust had been bestowed. And the simplicity of his words as he strove to comfort Mrs. Blumka's son after the death of his mother yet manages to embody the great warmth of the relationship and to convey a real sense of loss.

Ruth Blumka

THOMSON WORKS OF ART LIMITED

65 QUEEN STREET WEST
TORONTO, CANADA
M5H 2M8

LORD THOMSON OF FLEET
PRESIDENT

May 8, 1986

TELEPHONE (416) 364-8700
TELEX 065-24571

Mrs. Ruth Blumka,
Blumka Gallery,
101 East 81st Street,
New York, N.Y. 10028

Dear Mrs. Blumka,

 David and I were delighted to finally make your acquaintance yes-
terday through our mutual friend John Herring. Sometimes things work
out best on the spur of the moment. I did not know if it would be
possible on short notice to visit with you when I was in New York yes-
terday for the day. As it turned out, our meeting was a most memorable
and enjoyable experience.

 I had heard much about you, all of it highly favourable. In those
circumstances, it sometimes happens that expectation exceeds realiza-
tion, but certainly not in your case.

 It was so nice of you to open up the doors of your home to us so
that we might enjoy the wonderful works of art which you have collected
over the years. It is always a special joy to view works of art which
have been gathered together lovingly and with great expertise, not as
investments or as means of impressing anyone, but purely out of the
thrill and pleasure of collecting and enjoying them. Obviously, yours
is such a collection and you and your family must be extremely proud
of it.

 We will meet again, Mrs. Blumka, no doubt about that, and David
and I are already much looking forward to it. At that time perhaps we
will be able to show you photographs of some of the objects in our
collection. For now I simply wanted to write and thank you most warmly
for all your hospitality yesterday. It was a delightful experience
which we thoroughly enjoyed.

 David is returning home tomorrow with his Gothic bird cage. He
is a young man with very definite taste and the bird cage caught his
imagination instantly.

 With kindest regards.

 Yours sincerely

 THOMSON OF FLEET

TF.at

71

THOMSON WORKS OF ART LIMITED

65 QUEEN STREET WEST
TORONTO, CANADA
M5H 2M8

LORD THOMSON OF FLEET
PRESIDENT

May 16, 1986

TELEPHONE (416) 364-8700
TELEX 065-24571

Mrs. Ruth Blumka,
Blumka Gallery,
101 East 81st Street,
New York, N.Y. 10028

Dear Ruth,

This is the second letter I have written to you. The first one was full of gratitude for your hospitality; this one will be in the same vein, and with every bit as much justification, and more.

Our visit yesterday with you and Vicky was among the most enjoyable of its kind that I have ever experienced. Only memories of dear old Hermann are in the same category, and of course such never-to-be-recaptured events out of one's past are uniquely precious. Yesterday will in time be tomorrow's wonderful memory. Indeed, it already is!

You certainly were interested in the photographs I showed you. I expected you would be, but you lingered over them, studied the few provenances I had, and came to conclusions on your own as to period, etc.

I think what I showed you was a good cross-section of my collection. I have many more objects, some of them fine, some more interesting perhaps than great, but all with their own appeal to someone who likes small sculptures and beautiful objets d'art. As you will have noticed, I particularly like sculptures which have been created by direct carving and of course ivory and box-wood are materials which lend themselves beautifully to this sort of art. That is why I was immediately drawn to your wooden spoons which have been exquisitely carved and which I had not seen on my first visit.

As to your own fabulous collection it was quite enough to concentrate yesterday on just a few of your objects which particularly appeal to me.

...2

The ivory, copper-gilt and silver Adoration pax is a marvellous
little work of art. It would appeal to anyone who could understand
and appreciate its exquisite beauty and feeling. But I think it was
made especially for you and for me!

The Gothic crucifixion diptych wing is, as you say, very deeply
carved, and as well is beautiful. I wonder who has the other wing?
It would be wonderful if they could be re-united one day. But for
now yours is more than capable of holding its own by itself.

The little gold, rock crystal and enamel double drinking cup with
the enamel grouping of the Madonna and Child is also an exquisite
little object. What pleasure and satisfaction it must have given the
man or woman who created it.

David fell in love with the silver engraving and so did I al-
though it required David to open my eyes a bit on that beautiful lit-
tle object which I think had best be seen at eye level, or slightly
above, and in good light.

The two Renaissance ivory groups are later in period but extremely
fine and in remarkably good condition. They come up even finer on
close inspection than at a first fast glance which was all I was able
to give them last week.

Thank you, Ruth, for letting us study these beautiful objects in
detail. As you say, one has to hold such small works of art in the
hand to get a complete and true feeling for them.

It was nice of you to run upstairs (literally!) to get the Renais-
sance jewel to show us; it, too, was beautiful.

And I love the little Michael Mann pistol. Some people might
wonder why I would be attracted to such a small object but miniatu-
rization has always fascinated me, especially in art, and I find this
little object quite exquisite. Thank you for showing it to me. When
you invoice me for it, please do so in the name of Thomson Works of
Art Limited, a family art trust I have established for my children.

And thank you very much for the lovely lunch. It was delicious and
exactly what David, John and I wanted. We hope it did not in any way
create problems for the dinner you held last evening. Your dinner will
have been more elaborate than your luncheon but no more appreciated.

Everything was fine when I returned home last evening. I am
pleased that I visited with you yesterday when the weather was beau-
tiful in Toronto and acceptable in New York. This morning it was
pouring rain in Toronto.

Thanks again for everything, Ruth, and I look forward to our
keeping in touch. With kindest regards.

 Yours sincerely,

 THOMSON OF FLEET

TF.at

THOMSON OF FLEET

65 Queen Street West, Toronto, Ontario, M5H 2M8, Canada

October 11, 1994

Mr. Anthony Blumka,
Blumka II Gallery,
101 East 81st Street,
New York, N.Y. 10028

Dear Tony,

Marilyn and I were deeply saddened to have you inform us that your mother passed away yesterday. David and Lynne join in extending our most sincere condolences.

When my receptionist told me that you had called I immediately feared the worst. Marilyn and I have suspected for some time that Ruth's outward cheerfulness masked a health problem with which her courage was enabling her to live with stoic resignation. She was so cheerful and exuberant by nature. Even the inevitable could not subdue her.

We met Ruth those many years ago when I pursued the wonderful Pax which she eventually permitted me to add to my collection. For both aesthetic and sentimental reasons it remains one of my favourite pieces.

From then on it was a little business here and there, but that was incidental to the warm friendship that developed between us. We enjoyed her warmth and liveliness, and most of all her friendship which was always so sincere. She really did like to see us on the too-few occasions when we were in New York and we could all get together. And I assure you, Tony, that we enjoyed it every bit as much as she did.

Your mother was a lovely person. Anybody who was privileged to know her as we did would share that feeling. She was a straight shooter. She could be trusted completely, both professionally and personally. She enjoyed life to the full and nothing gave her more pride and pleasure than her own family. She cherished her friends, too, and Marilyn and I were proud to be among them.

These will be difficult and sad days for you and your family, Tony, but you will have so many happy and proud memories. These, and the passing of time, will ease your burden.

Marilyn and I and our family want you to know that we are thinking of you.

With kindest personal regards.

Yours sincerely,

TF.at
blumka02

A Gallery of European Works of Art

WOOD-CARVING

27
Brescia, Italy
**'Monumentino': Sculptures and
tools of Ottaviano Jannella**
(1635–1661)
Boxwood, metal, glass, paper;
portrait engraving of Jannella by
Bernardo Consorti (1780–1859)
21 × 38.1 × 18.4 cm

28
The Netherlands,
probably Antwerp
**Mirror frame with Judith
and Holofernes**, *c.* 1570–80
Boxwood
12.7 × 10.2 × 1.3 cm

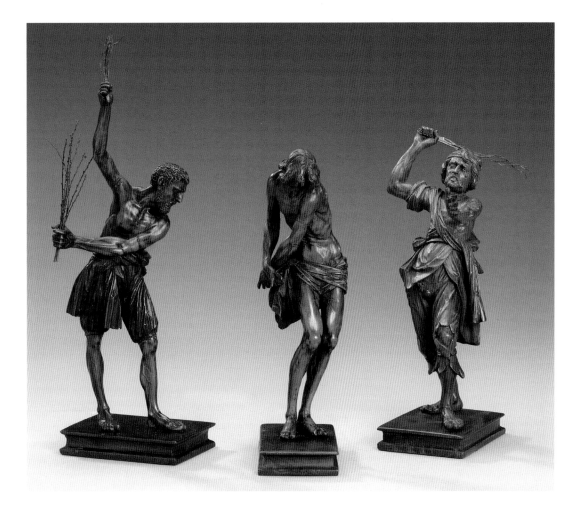

29
South Germany: follower of
GEORG PETEL
(1601/02–1634)
The Flagellation of Christ
c. 1630–40
Fruitwood
Christ 19.1 cm high

30
Antwerp: workshop of
MATTHIEU VAN BEVEREN
(1630–1690)
Joseph and the Christ Child
2nd half 17th century
Boxwood
Height 30.5 cm

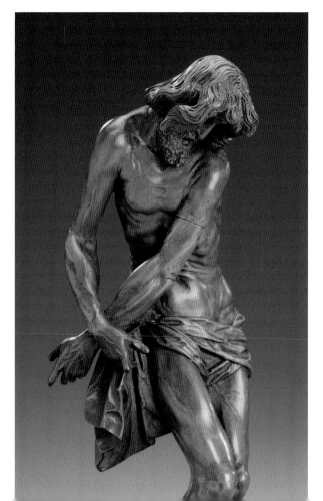

31
Austria, probably Vienna
IGNAZ ELHAFEN
(1618–1715)
Turkish Lion Hunt, c. 1680–90
Pearwood
12.7 × 20.3 cm

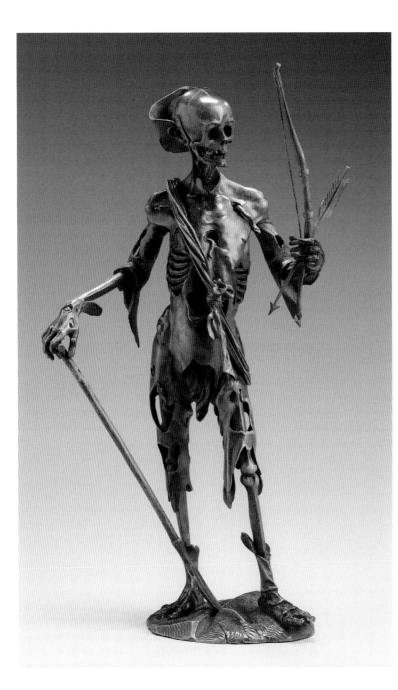

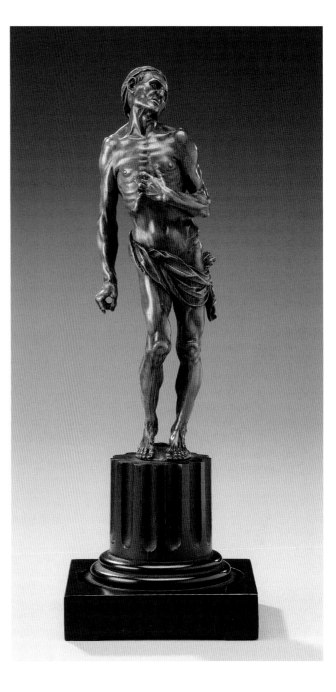

32
Germany (Bavaria?)
Death triumphant, *c.* 1670
Lindenwood
Height 24.1 cm

33
Germany
Old Age, early 17th century
Boxwood
Height 15.9 cm

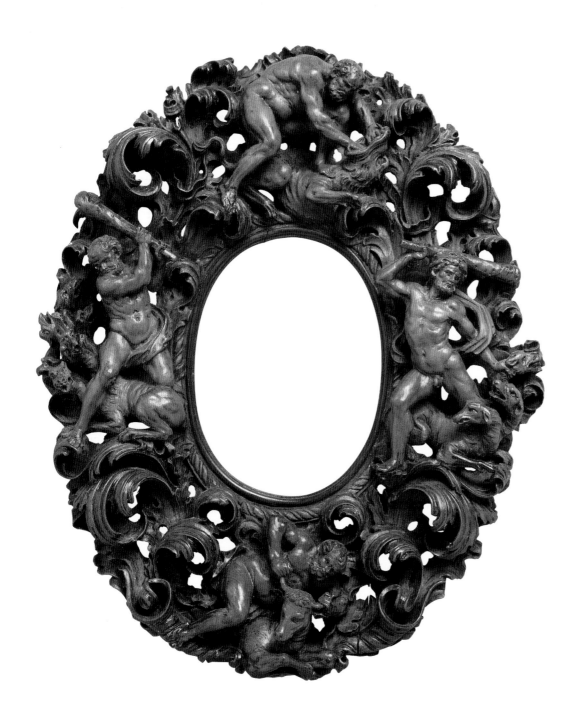

34
Belluno, Italy: attributed to
ANDREA BRUSTOLON
(1662–1732)
**Frame with Four Labours
of Hercules**
1st quarter 18th century
Boxwood
20.6 × 17.5 cm

35
Germany: after
CHRISTOPH WEIDITZ
(c. 1500–1559)
**Hercules with the Apples of
the Hesperides**, 18th century
Boxwood
With base, 45.1 cm high

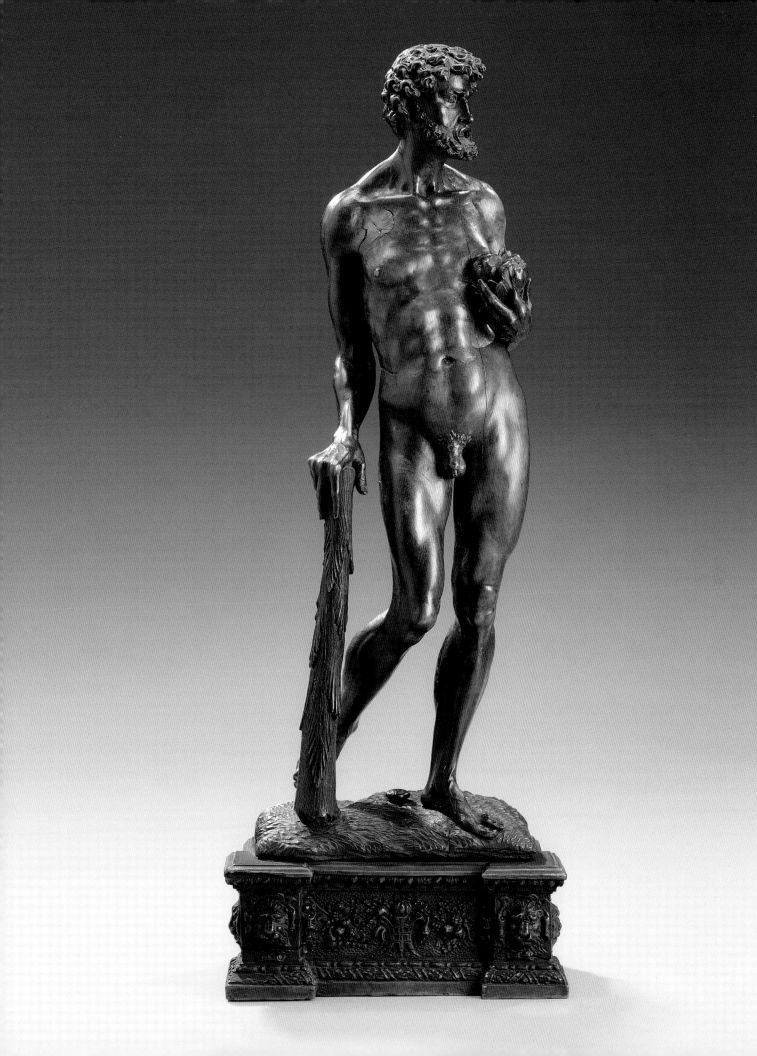

36
Bourg-en-Bresse, France
JEAN DE MARENDE
(active early 16th century)
**Philibert the Fair, Duke of Savoy,
and Margaret of Austria**
obverse, 1502
Gilt bronze
Diameter 103 mm

37
Augsburg
CHRISTOPH WEIDITZ THE ELDER
(c. 1500–1559)
**Model for a medal of
Lienhart Schregl** (died 1534), 1528
Boxwood
Diameter 62 mm

38
Ulm
THE BELTZINGER MASTER,
probably MARTIN SCHAFFER
(1477/79–1549)
Hans Beltzinger, 1529
Pearwood
Diameter 63 mm

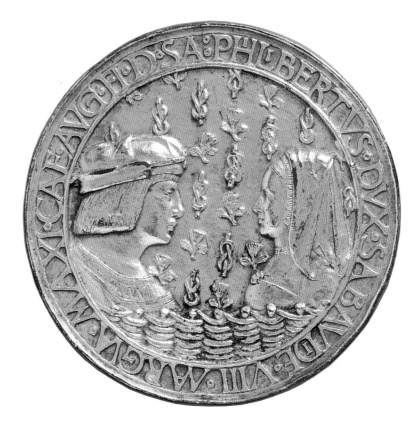

39
Augsburg: attributed to
FRIEDRICH HAGENAUER
(1490/1500–after 1546)
**Model for a medal of Count
Raimond Fugger** (1489–1535)
obverse, 1527
Boxwood
Diameter 63 mm

40
Augsburg
THE MASTER OF BLAURER
(active 1527–45)
**Model for a medal of
Wolfgang Volkra** (1480–1531),
Councillor to the King of Hungary
obverse and reverse, 1527
Boxwood
Diameter 86 mm

41
Florence: possibly
workshop of
GIUNTA DI TUGIO
(died *c.* 1466)
**Pharmacy jar with
oak leaf and dog pattern**
c. 1420–50
Tin-glazed earthenware
21.0 × 24.1 cm

42
Venice
**Plate with the coats of arms
of Georg Scheurl and Elizabeth
Derrer of Nuremberg**, *c.* 1554
Tin-glazed earthenware
Diameter 30.5 cm

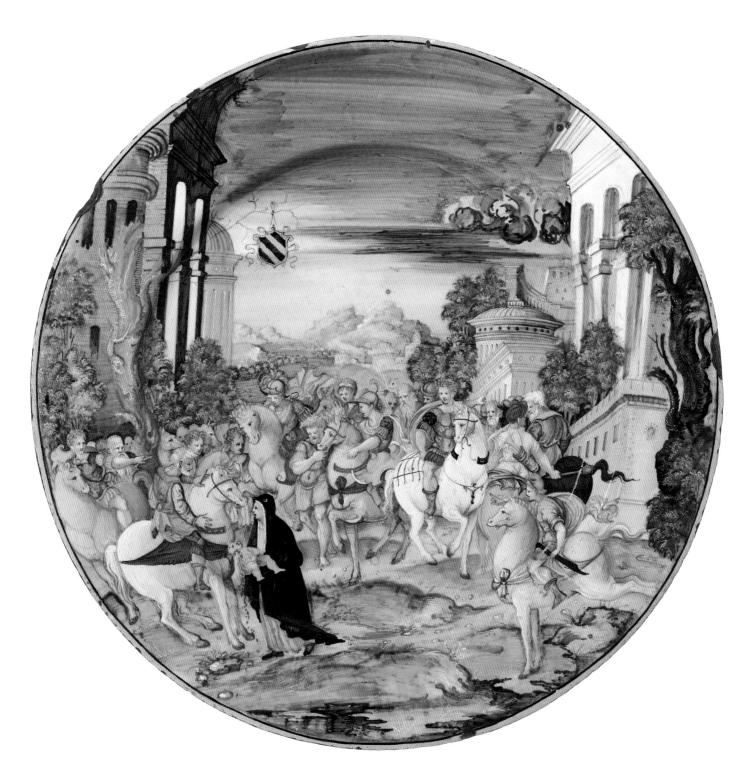

43
Urbino: circle of
NICOLA DA URBINO
(c. 1480–1537/38)
Plate with the Justice of Trajan
c. 1530–35
Tin-glazed earthenware
Diameter 48.3 cm

44
Austria, probably Innsbruck
LEONHARD MAGT
(died 1532)
Adam and Eve, *C.* 1520
Bronze
With pedestal , each 33 cm high

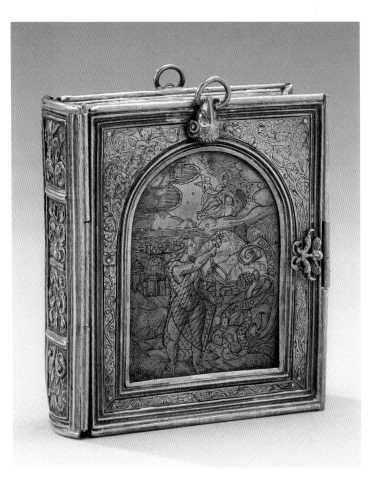

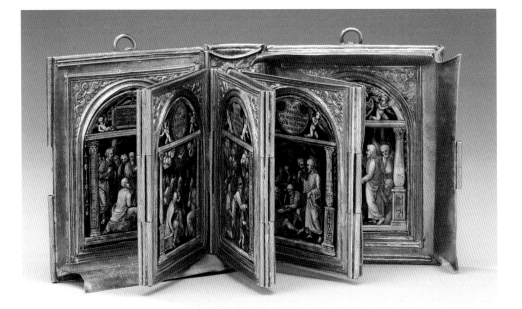

45
Limoges: attributed to
MASTER KIP, possibly
JEAN POILLEVE
(active *c.* 1537–59) and
MARTIAL COURTEYS
(died 1592)
**Book of hinged panels with
imagery on the theme of
the Lord's Prayer**
mid 16th century
Enamel on copper, gilt metal
and silver
Open, 9.5 × 18.5 cm

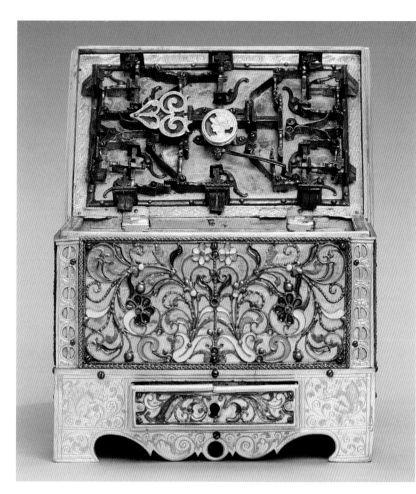

46
Nuremberg
MICHEL MANN
(1560/70–1630)
Casket with scenes from
Genesis: Eden, Adam,
The Fall, The Expulsion,
Noah's Ark, Moses
c. 1630
Gilt silver, gilt copper,
silver and enamel
8.9 × 6.3 × 6.3 cm

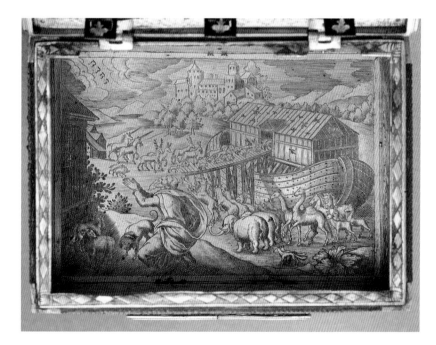

47
Ulm and Zurich
DAVID HESCHLER
(sculptor, 1611–1667)
and HANS RUDOLPH ULRICH
(silversmith, 1589–1667)
**Cup cover with Hercules
supporting the Heavenly Sphere**
c. 1630–40
Boxwood, silver and gilt silver
Height 30.5 cm

48
Augsburg
CHRISTOPH LENCKER
(1556–1613)
The Lamentation over Christ
c. 1595–1600
Silver
Height 17.8 cm

49
Königsberg
CHRISTOPH DRESCHER
(active 1594–1626)
Covered tureen (arms of
the von der Linde family)
c. 1620
Gilt silver
19.1 × 33 cm

50
Germany, probably Dresden
Shell cup, *c.* 1720
Green snail-shell, gilt silver,
emerald, portrait cameo
Height 33.7 cm

51
Augsburg
PAUL HUBNER
(died 1614)
**Flagon with mythological
figures and masks**, *c.* 1600
Parcel-gilt silver
30.5 × 15.2 cm

ALABASTER

52
Nuremberg
PETER EHEMANN
(active *c.* 1510–58)
Ecce Homo, *c.* 1530
Alabaster
13.3 × 8.9 cm

IVORIES

53
Munich: attributed to
CHRISTOPH ANGERMAIR
(*c.* 1580–1633)
**Judith with the Head of
Holofernes**, *c.* 1630
Ivory
18.4 × 14.6 cm

54
Schwäbisch Hall and Augsburg
JOHANN MICHAEL HORNUNG
(ivory carver, 1646–1706)
and ELIAS ADAM
(silversmith, 1669–1745)
Tankard with a battle scene
1679
Ivory, gilt silver
Height 31 cm

55
Vienna
IGNAZ ELHAFEN
(ivory carver, 1658–1715)
and OCTAVIAN COCSSEL
(silversmith, active 1691–1716)
**Tankard with the Abduction of
the Sabine Women** (sleeve) **and
Samson and the Lion** (finial)
1697
Ivory, gilt silver
Height 31.8 cm

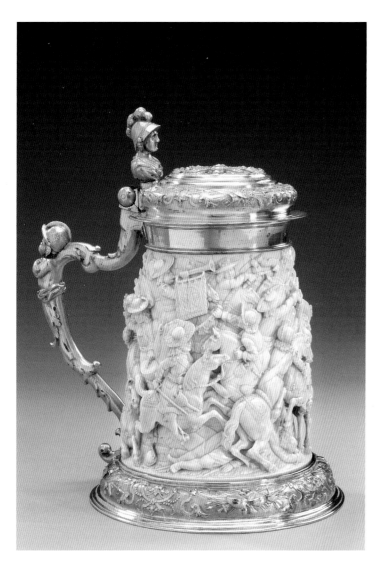

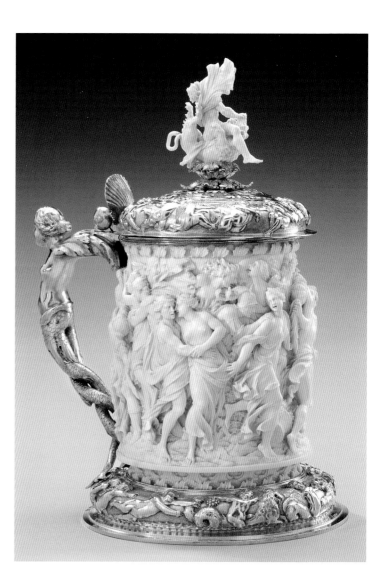

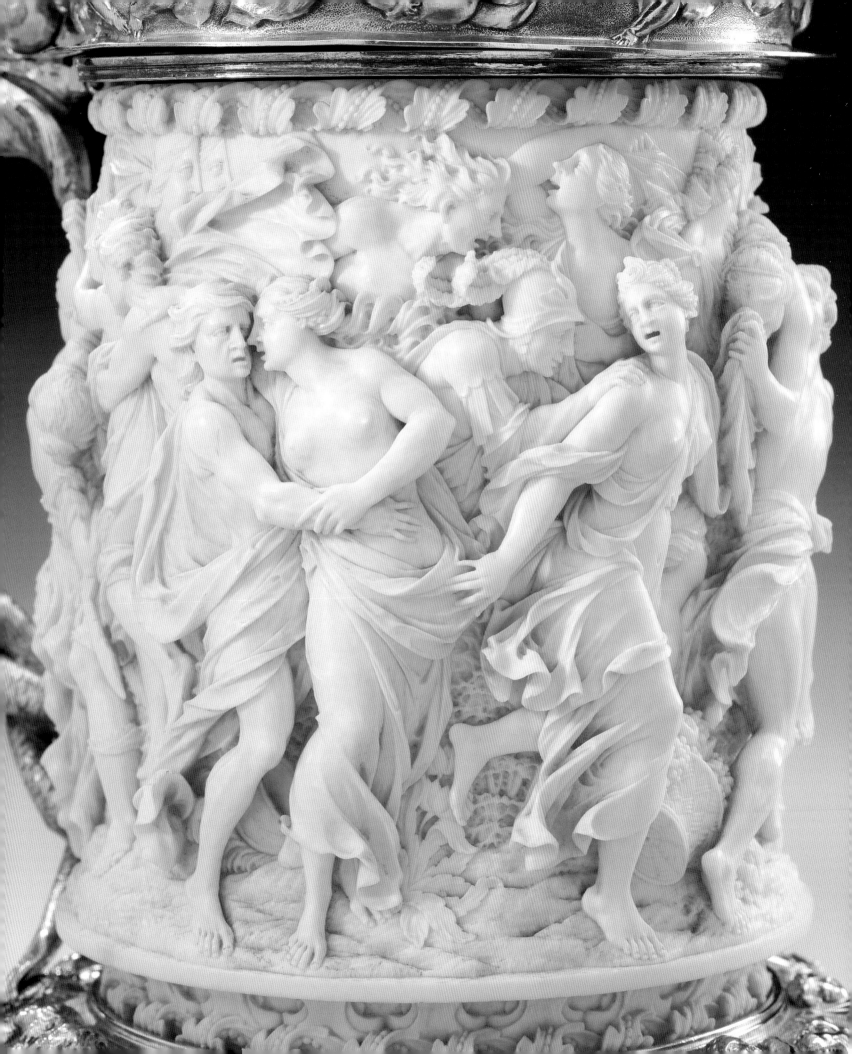

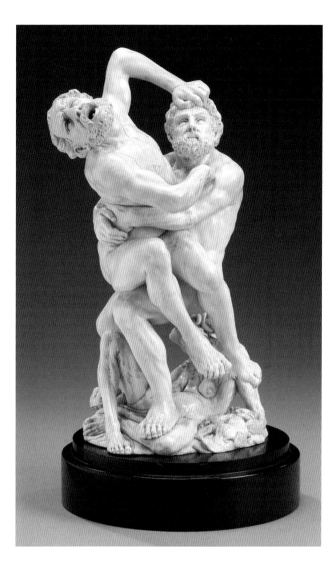

56
Gdansk (Danzig)
CHRISTOPH MAUCHER
(1642–after 1721)
**Hercules and Antaeus
with a Fury**, before 1695
Ivory
Height 30.5 cm

57
BALTHASAR GRIESSMANN
(c. 1620–1706)
The Fall of Man
c. 1670–90
Ivory
Height 32.7 cm

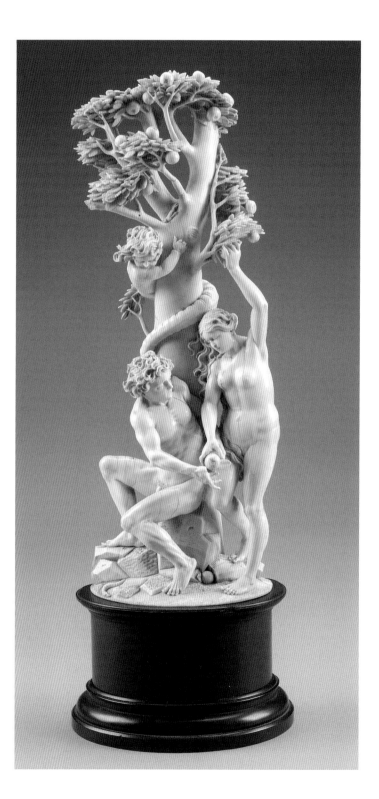

58
Rome
FRANS VAN BOSSUIT
(1635–1692)
The Flaying of Marsyas
c. 1670–75
Ivory
22.9 × 11.4 cm

59
England
DAVID LE MARCHAND
(1674–1726)
**Anne Churchill, Countess
of Sutherland, and her
Daughter Anne, later
Viscountess Bateman**
c. 1710
Ivory
19.1 × 13 cm

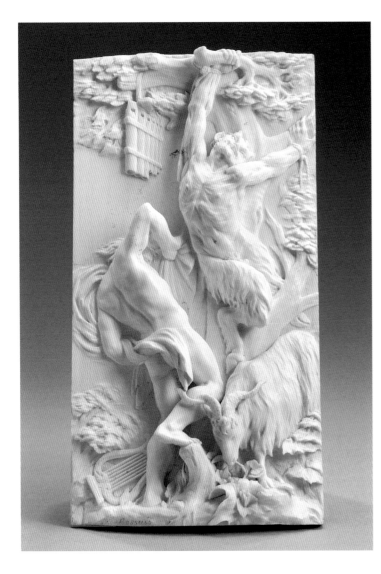

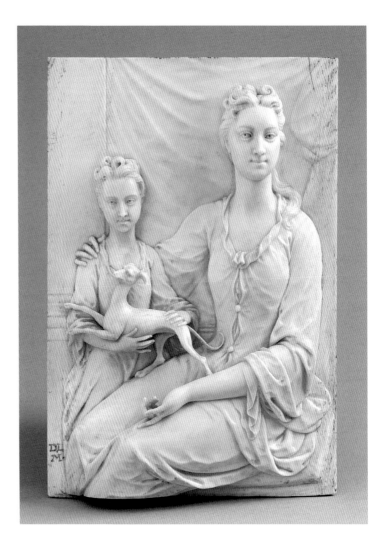

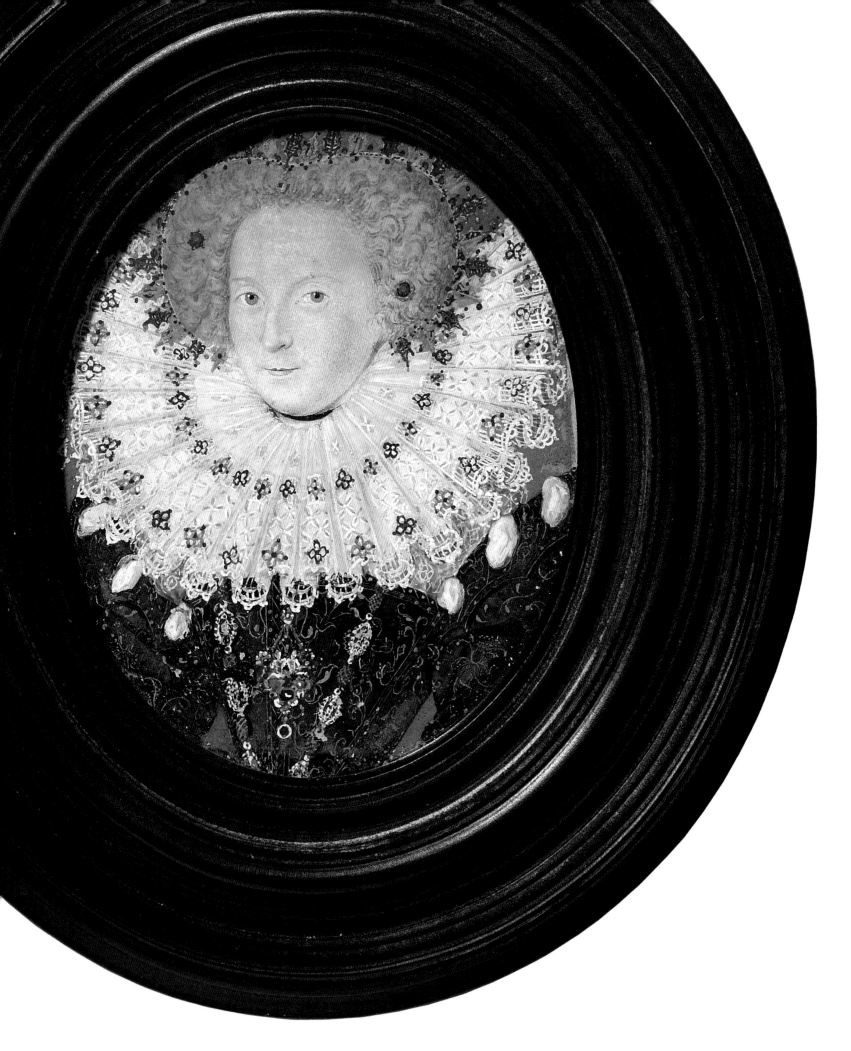

Portrait Miniatures

GRAHAM REYNOLDS

Ken Thomson began collecting portrait miniatures in 1954. His earliest purchase was a portrait of a lady by the great seventeenth-century English miniaturist Samuel Cooper. This was joined over time by works by a number of late eighteenth-century English masters, including Jeremiah Meyer, Richard Cosway, James Scouler, John Smart and Richard Crosse. For the deaf-and-dumb miniaturist Richard Crosse, by whom he ultimately acquired four works, Ken Thomson had a particular penchant. This enthusiasm would have pleased Basil Long, founder of the contemporary study of miniatures, who wrote an account of Crosse. Apart from the distress of his affliction, Crosse's life was embittered by a thwarted love affair. Crosse wished to marry his cousin Sarah Cobley, but she was already engaged to the printer Benjamin Haydon. Her son, Benjamin Robert Haydon, who was more gifted as a writer than as a painter, movingly records an account of the chance meeting of Crosse with his dying mother, which reduced the rejected lover to paroxysms of inarticulate grief.

In preferring Smart, by whom he had ten examples, to Cosway, by whom he had two, Ken Thomson was in tune with the taste of his own time. In the painters' lifetimes it was Cosway who was fashionable, with entrée to the court and a dashing social life. Smart, with no such advantages, sought a fortune in India. Cosway was the more original and perceptive painter, but Smart's uniform smoothness and enamel-like finish has had more appeal to recent collectors.

The representation of seventeenth-century miniaturists in the Thomson Collection begun by Ken's first purchase was expanded to include works by John Hoskins, Cornelius Johnson, Nicholas Dixon, Richard Gibson and Peter Cross. It was further enlarged by examples of the specialized technique of the uncoloured plumbago portrait (plumbago is a type of graphite), practised notably by Thomas Forster, David Paton and David Loggan.

Unlike Queen Elizabeth I, who kept her miniatures wrapped in paper, Ken Thomson preferred them in contemporary frames and liked to contemplate the framed work as a complete artefact. Hilliard's miniature of Jane Coningsby (fig. 61) is notable for being preserved in its original case, a circumstance which led Ken to pay £60,000 for it – then the record price paid for a portrait miniature. One of his last purchases was a rectangular miniature by Hilliard of a lady aged thirty in 1582 (fig. 63): bringing the number of portraits by this pre-eminent Elizabethan artist to five, this made his collection of Hilliards quite outstanding. Another fine portrait of the same period, representing Lord Darnley (fig. 60), consort of Mary Queen of Scots and father of James I and VI, has a notable enamelled frame.

60

English School, mid 16th century
(1510–20?–1576)
**Lord Darnley (Henry Stuart, Earl of Ross
and 1st Duke of Albany)** (1545–1567), *c.* 1560
Watercolour on vellum, backed with wood,
oval 38 mm high, with enamelled gilt-metal frame

Comparison with attested portraits of Lord Darnley,
whom his wife Mary Queen of Scots described as
"the lustiest and best proportioned long man that
she had seen," makes the identification of the sitter
very likely, if not certain. However, the date given in
the inscription, 1560, conflicts with the age given,
eighteen: in 1560, when Darnley met Mary for the
first time, he was fifteen. The couple were married
in 1565, but Darnley very soon became overbearing
and two years later was murdered.

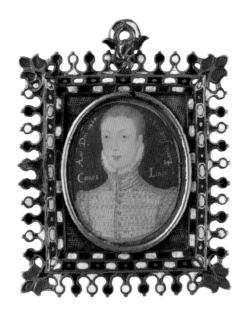

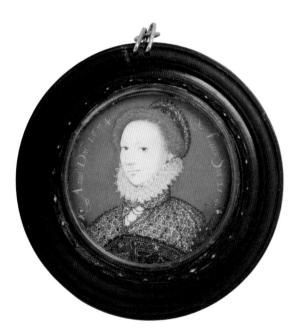

61

NICHOLAS HILLIARD
(1547–1619)

Jane Boughton, née Coningsby (born 1553), 1574
Gouache on vellum, 43 mm diameter, in an original
turned circular frame of ivory and tortoiseshell

Hilliard became a 'limner' when his apprenticeship
to the goldsmith Robert Brandon expired in 1569.
This is one of the earliest of his portrait miniatures
to show the full range of his powers. The frame, in
the circular shape popular at the time, is the earliest
example to be made of stained ivory that is known.

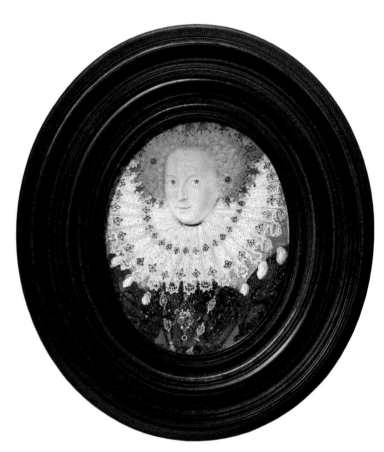

62

NICHOLAS HILLIARD
(1547–1619)

Lady Anne Hundson, 1585
Gouache and watercolour
on vellum and card
62 × 53 mm

63

NICHOLAS HILLIARD
(1547–1619)

An Unknown Lady aged Thirty, 1582
Gouache on vellum, laid on a playing card (the ace
of hearts), 65 × 45 mm (original support extended
by the artist with a strip of vellum of 5 mm)

Unknown before 2002, this miniature was
immediately recognized as a masterpiece of
Hilliard's maturity. The sympathy with his subject
shown here and in the previous and following
portraits bears out the artist's belief that the painter
should be attracted by his sitter: "Wherefore it
behoveth him that he be in heart wise, as it will
hardly fail that he shall be amorous …. How then
can the curious drawer watch and as it were catch
those lovely graces, witty smilings, and those stolen
glances that suddenly like lightning pass, and another
countenance taketh place, except to behold and very
well note and conceit to like? So that he can hardly
take them truly, and express them well, without an
affectionate good judgment and without blasting
his young and simple heart" (*The Arte of Limning*).

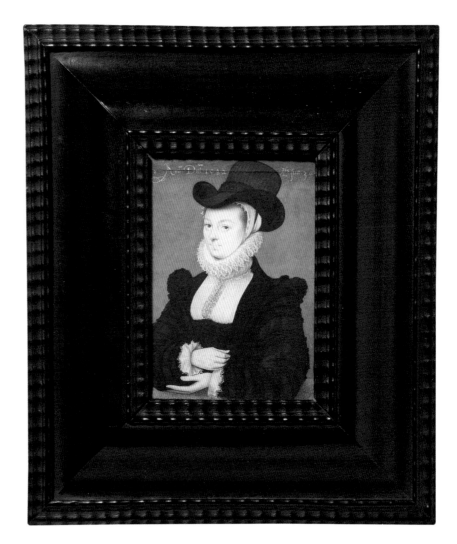

64
ISAAC OLIVER
(c. 1565–1617)
Edward, Baron Herbert of Cherbury, 1616
Signed with initials IO and dated, upper right
Gouache and watercolour on paper
53 × 45 mm

65
JACOB VAN DOORDT
(died 1629)
A Lady
1612
Watercolour on vellum
Height 48 mm

66
JOHN HOSKINS
(1560–1665)
A Gentleman
c. 1650
Height 55 mm

67
PETER OLIVER
(1589–1647)
William Drummond of Hawthornden
c. 1615
Height 43 mm

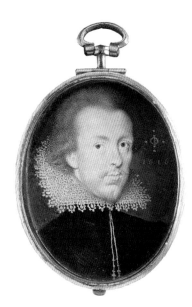

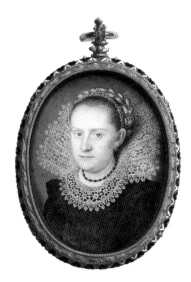

68
SAMUEL COOPER
(1607/08–1672)
Young Lady wearing a Blue Dress, *c.* 1650
Inscribed with initials SC
Watercolour on vellum, in original
gold locket within contemporary frame
Oval within frame 68 × 57 mm

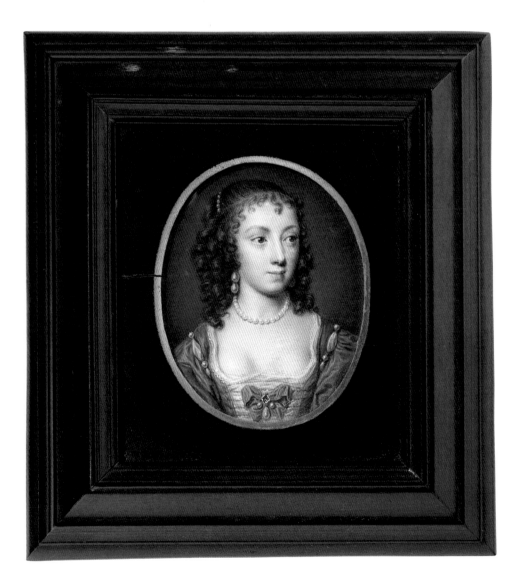

69
PETER OLIVER
(1589–1647)
King Charles I as a Boy, 1610
Pencil
70 × 55 mm

70
JOHN HOSKINS
(1590–1665)
A Nobleman, 1649
Signed IH and dated
Watercolour on vellum
Height 102 mm

71
NICHOLAS DIXON
(c. 1645–after 1708)
**Sir Willoughby Aston,
Sheriff of Cheshire**
c. 1690
Signed ND
Oil on vellum
Height 73 mm

72
RICHARD CROSSE
(1742–1810)
Boy wearing a Red Coat, 1770
Signed and dated on reverse
Watercolour on ivory, in original gold frame
37 × 30 mm

73
RICHARD CROSSE
(1742–1810)
Little Girl, 1782
Signed and dated on reverse
Watercolour on ivory, in original gold frame
33 × 28 mm

74
JEREMIAH MEYER
(1735–1789)
An Officer, c. 1760–89
Enamel on gold, in gold frame
with diamonds
Oval within frame 29 × 25 mm

75
JOHN SMART
(1741/42–1811)
Major Banks, 1787
Signed JS and dated; reverse with initials JS
in seed pearls on hair
Watercolour on ivory, in original gold
and pearl frame
Oval within frame 52 × 38 mm

76
JOHN SMART
(1741/42–1811)
Mr. Witherbro, 1790s
Signed; instructions engraved on reverse
Watercolour on card
Oval within frame 57 × 40 mm

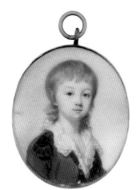
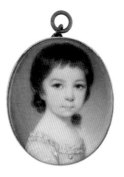
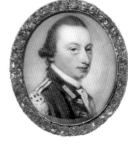
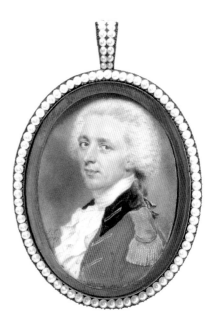
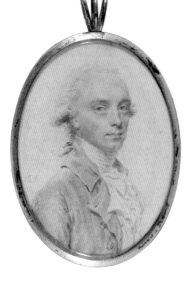

77
SAMUEL SHELLEY
(1756–1808)
Young Man, *c.* 1790
Signed; with address on reverse
Watercolour on ivory, reverse
with blue glass, gilded wire,
hair, seed pearls and opal glass
75 × 60 mm

78
RICHARD COSWAY
(1742–1821)
**Young Lady wearing
a Portrait Miniature**, *c.* 1790
Watercolour on ivory
63 × 50 mm

79
RICHARD CROSSE
(1742–1810)
Self-portrait, *c.* 1790–92
Watercolour on ivory
Oval within frame 100 × 80 mm

80
JOHN SMART
(1741/42–1811)
Lieutenant J. Sol, 1803
Signed JS and dated
Watercolour on ivory, gold frame,
hair, seed pearls in leather-covered
fitted case with silk lining
78 × 60 mm

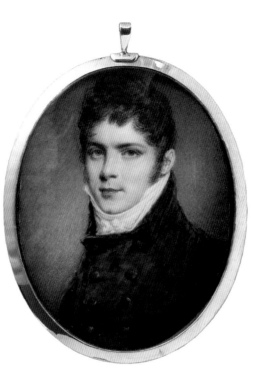

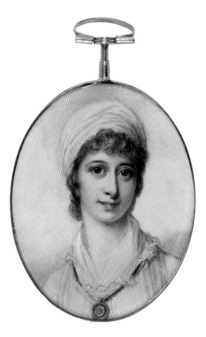

81
JOHN SMART
(1741/42–1811)
Michael Topping (1747–1796)
1795
Pencil
Oval 148 × 130 mm

Beauty is the Eye Discovering: Ken Thomson's Passion for Canadian Historical Art

ANNA HUDSON

I met Ken Thomson, Lord Thomson of Fleet, only once but was astonished by his curatorial instinct. He was describing how works from his collection might be installed in the Thomson wing of the Art Gallery of Ontario. From memory he played objects against one another to create new and unexpected meanings. A curator at a public gallery at the time, I had never encountered, or imagined, a collector taking such curatorial initiative. It is one of the tasks of a curator to spark new insights into works of art in exhibitions. So that the objects would 'speak' to gallery and exhibition visitors, I would choreograph and moderate visual conversations among the works of art on show. As I observed Ken's playful fascination for objects the more I appreciated his curatorial talent. As a collector, moreover, he could do more than the institutional curator, given his complete dedication to the object and the tremendous resources he brought to building his collection.

I now realize that the collector can be, as in the case of Ken Thomson, an invaluable curatorial colleague. And yet this claim runs counter to the long-standing separation in Canada of the private sector, represented by the collector, from the public sector, the curator working in the public art gallery. The two have long been considered opposites, at least in motivation. What conditioned this separation, and what purpose can it have served? It goes back to the Second World War, when government (federal, provincial and civic) took on greater responsibility for public culture in Canada. Today, with declining government support for the visual arts, the future depends on fruitful public and private sector partnerships. With this recognition must come a serious reconsideration of the collector's contribution.

Public art galleries in Canada have been subject to increasing public pressure to be *relevant* in contemporary society. How this might be evaluated is forever elusive. Meanwhile increasing pressure for public accountability of government funding to public cultural institutions has led to increased suspicion that the curatorial profession is elitist and self-serving. What, after all, can be the larger public good of curatorial object knowledge? Curators, however, now work with educational teams with the aim of making artworks touchstones for the public imagination. To this end curators of historical art must also bridge the expanse of time separating the work's production from its contemporary existence. While these changes in Canadian museology have had the good effect of focusing attention on the gallery as a site for social communication, they have also reduced confidence in the importance of an institutional collection as a foundation and resource.

Object knowledge has lost its cachet. The result is the current identity crisis of museums (as it is labelled in the museological literature). Public art galleries are, of course, founded on collections donated by collectors. While the collectors' object knowledge and interest in object relationships should make them curatorial allies, public art galleries in Canada are less

82
TOM THOMSON
(1877–1917)
Autumn's Garland, c. 1916
Oil on composite
wood-pulp board
21.5 × 26.7 cm

83
TOM THOMSON
(1877–1917)
Storm Clouds, fall 1915
Oil on composite
wood-pulp board
21.7 × 26.8 cm

trusting of this expertise, hesitating to regard it as central to institutional relevance. The acquisition of art is, moreover, so costly that it has inevitably been reduced in the public sector. The result: a widening gap of public versus private interest in visual culture and art history, into which the work of art disappears.

From my own perspective the essential similarity between the curator and the collector is their common expertise as choreographers of art objects. Ken Thomson excelled at this skill and sought to exercise it on the scale of a public art gallery. He had an almost photographic memory of his collection. By tumbling mental images of works around in multiple configurations, he came up with combinations which would otherwise have taken an enormous amount of physical effort to achieve in the public institution. The curator hauls works out from the vaults only with the help of a team of preparators, heaving together an exhibition as expediently and with as little experimentation as possible. While every tiny spark of aesthetic comprehension this process ignites is a treasure, the number of occasions to explore it are very limited. Ken, meanwhile, by virtue of his constant sifting and reorganizing of his collection, not to mention his regular injection of new acquisitions, orchestrated an opus of object relationships. A collector has to be measured by more than the list of their purchases. That 'something extra' is where the curator and the collector meet and where Ken may be seen as a visionary collector of Canadian historical art.

Beauty is the Eye Discovering

84
TOM THOMSON
(1877–1917)
Snowy Trail, Algonquin Park, 1914
Oil on composite wood-pulp board
21.5 × 26.8 cm

Students of art history, as I now observe teaching at a university, are not trained to value the object. They rarely see the actual 'thing.' The opportunity to study of works of art is too rare, which strikes me as odd, given the claims of Western society's sophisticated visual literacy. I can attest that this situation bodes particularly badly for historical Canadian art, which quickly appears irrelevant. 'Creampuffs and Hardball: Are You Really Worth What You Cost or Just Merely Worthwhile?' was Stephen Weil's 1995 critique of a museum that haunts public art galleries especially in North America.[1] Vituperative demands for public accountability have pushed museums to defend their relevancy on the basis of balanced account books. But such 'fiscal relevancy' tends not to favour the acquisition or exhibition of art. The rhetoric of the relevance of art, and of art galleries, circumvents the object and, I should add, is always suspect as being academic, elitist (and with it the academically trained curator). The answer given to the question why 'Art Matters,' to recall the AGO's hugely successful button campaign, is not the object itself. Even UNESCO's statement about public collections reads abstractly: "A museum works for the endogenous development of social communities whose testimonies it conserves while lending a voice to their cultural aspirations."[2]

Weil warned that the museum must concentrate "on those object-related outcomes that are most distinct to museums and not inadvertently undermine its unique importance by describing outcomes that might easily be achieved by some other organization."[3] He is wary of the imperative "to be relevant and to provide the most good in society."[4] This desire, writes Gail Anderson, is at the heart of the current paradigm shift from the traditional museum (as elitist, exclusive, ethnocentric and paternal) to the reinvented museum (as equitable, inclusive, multicultural, open, welcoming and dialogic).[5]

The simple opportunity for a playful and creative engagement with the history of Canadian art afforded by the collection is painfully overlooked. Should the gallery experience not be an exercise in seeing and speaking through the object to one another, bridging cultural and generational gaps, and thinking together about art? In the absence of sufficient access to the works of art this is impossible. Although public collections of historical Canadian art are held in the major urban centres, without institutional support for increased and dynamic exhibition of the collections an intimate appreciation of the art by the public is impossible. What is at stake is that 'live' relationship with the object which the curator and the collector share. But it is precisely this that would make the gallery experience of art relevant.

Around 1990, when I was a graduate student in art history at the University of Toronto, I visited Ken's office in the Thomson building with fellow members of the University's Hart House Art Committee. I remember a suite of rooms full of paintings, largely by the mid-

nineteenth-century painter of life in early Canada, Cornelius Krieghoff (fig. 86). Ken's office revealed his close and intimate study of art. Clearly he lived and worked with these objects. In 1989 he moved just over 400 paintings and sketches to a generous space on the ninth floor of the Queen Street location of the Bay (as the Hudson's Bay Company became known under the direction of the Thomson family; fig. 85). Ken delighted in the Thomson Gallery and "to be able to make them [the objects] available to those who enjoy them as I do."[6] Dealers, auctioneers, conservators, framers and curators with whom Ken held trusted professional relationships knew him as a passionate collector with a remarkable ability to remember compositional detail. They knew he never stopped looking, searching and acquiring. The profound joy Ken had in narrating his collection with others set him apart as a collector.

Ken wished to see his complete collection on display at the AGO and, like a curator, imagined constantly evolving exhibition configurations. Had Ken lived to experience the opening of the Thomson Canadian wing he would have delighted in engaging visitors in the act of looking at the

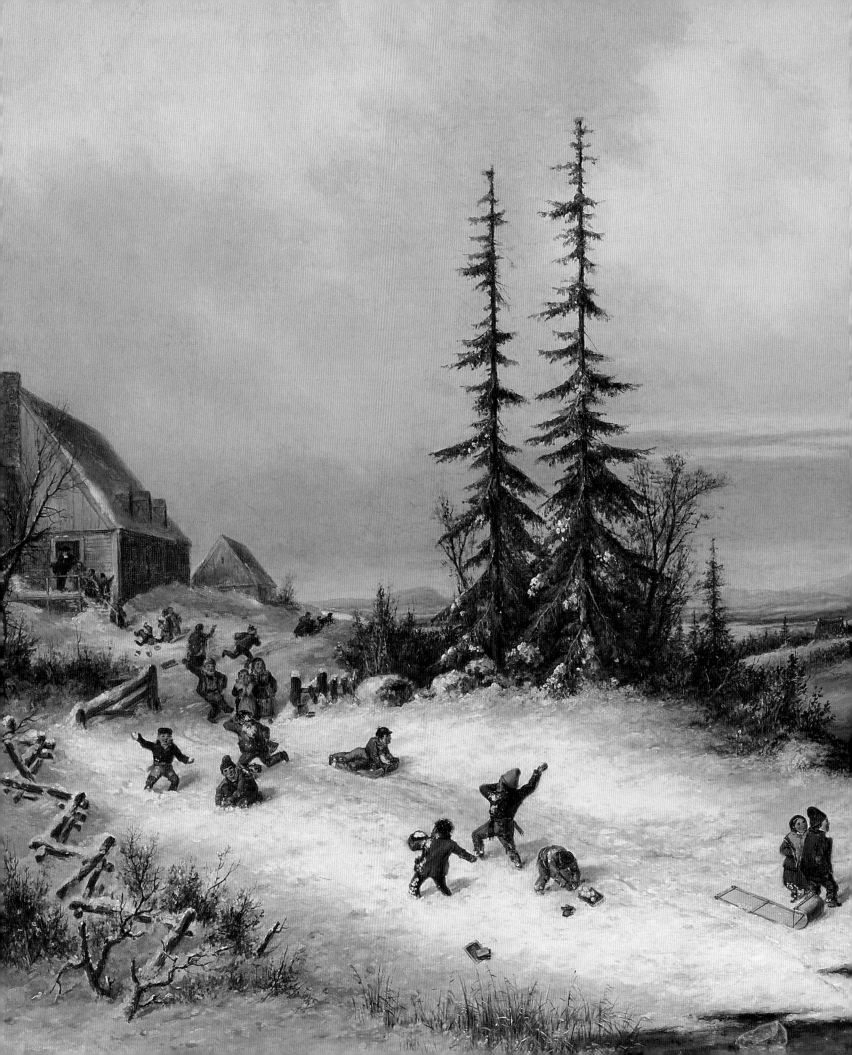

86
CORNELIUS KRIEGHOFF
(1815–1872)
Playtime, Village School
c. 1857
Oil on canvas
63.4 × 91.4 cm

work he had so carefully chosen. And an expansive engagement with the object's narrative potential is what public art galleries should crave for their visitors. This is what makes public collections of art relevant. Ken had the prescience to recognize that relevance depends, most simply, on exposing the public to as much art as possible and to ensure collection installations regularly change. He set out to create such a repository and provide access to it for the public. With this in place object knowledge can develop and with it the narration of the art exchanged between people. The French cultural theorist Nicolas Bourriaud has described art's power to function as a social interstice.[7] For Bourriaud the point of much contemporary art practice is its relational aesthetic: art is not utopian or removed, but actual and existing in a social environment. Though the kind of art involved may be different, this is certainly not incompatible with Ken's approach. For Ken the experience of historical Canadian art was ultimately object-bound; how much the piece yields in the present in breadth and depth of visual exploration is its worth. He constantly traded up, aiming to leave the AGO with the highest quality of Canadian historical art possible.

Idiosyncratic personal meaning-making, as described by the former head of public programs at the Vancouver Art Gallery, Cheryl Meszaros, typifies the art gallery experience of the general public. It means you can think whatever you want about a work of art; the gallery does not or is unable to provide a structure for interpretation of the collection. Meszaros struggles to redefine parameters for the museum experience and arrives at the concept of the "social imaginary."[8] The term invites educators to consider the history of the museum collection as a kind of sociology lesson. What weight of time do the objects hold in terms of how we imagine our collective selves? "The Mindful Museum," writes the journalist Adam Gopnik, "as I imagine it, would put art in your face from the moment you enter and force you to confront it . . . as something that is intrinsic to it – intrinsic to its every moment."[9] The intrinsic is the untranslatable: Gopnik disparages wall labels and explanatory texts not because he is elitist but because he sees the gallery as a place of visual conversation. The significance of talking to each other in a gallery is tied, he suggests, to the experience of the exhibition of works of art. "Above all, the mindful museum will be concerned with time, will be concerned with articulating the human time in which we live and which the museum alone, among all our institutions, articulates best."[10] And so the museum is neither a shopping mall nor a mausoleum. It must be of the moment and utterly devoted to the exploration of a collective understanding of the connection between human time and the universal time proffered by art. Both Gopnik and Meszaros are keen to reaffirm the social dimension of gallery experience. Ken's solution was pragmatic: create a collection of major works, share it as broadly as possible, and be sure to invest personally in the communication of art appreciation.

87
DAVID ALEXANDER COLVILLE
(1920–)
Soldier and Girl at a Station, 1953
Glazed tempera on hardboard
40.6 × 61.0 cm

Ken insisted on coming to his own conclusions about works of art. He did not defer to an expert, although he often sought the opinions of others. In spite of his wealth, he was a humble man, self-taught and unpretentious. Yet he had tremendous knowledge of objects, won through extensive research of public and private collections, in addition to his constant surveying of art on the market. Recently the American curator and journalist Jane Kallir has considered how the knowledge and resources of the collector have reconfigured the art world in North America. In the United States, where the private sector has always played a more public role, the collector's increasing financial authority is causing concern.[11] In an article of 2007 titled, 'The problem with a collector-driven market,' Kallir claims: "For the past century or so the art world has been supported by four principal pillars: artists, collectors, dealers and the art-historical establishment (critics, academics and curators)"[12] She contends that today "collectors have taken charge."[13] Kallir's article is a timely acknowledgement of contested authority. Who is, or should be, in control of the art gallery: the public or private sectors? Or is there a middle ground?

'To Have and Give Not' was the bold *New York Times* tagline in February 2008 for the surprising insistence of Eli Broad, the American billionaire philanthropist, on an "open" donation – whereby the donor maintains involvement in the stewardship of his collection.[14] The subheading 'Greatness Beckons, but a Museum's Patron Stops Short of the Ultimate

Beauty is the Eye Discovering

Gift' referred to the prestige museums have enjoyed in securing private fortunes – miraculously transforming individual wealth into public 'good.' Broad rescinded his promise to donate his collection to the Broad Contemporary Art Museum, a proposed multi-million dollar addition to the Los Angeles County Museum of Art "for which he chose the architect and paid the bill."[15] Broad figured a controlled loan of works was better than an outright gift if he wished to avoid the risk of his works of art being largely relegated to storage. In my own experience, too, donors are loth to see their gifts descend into the vaults. What they feel is a sense of loss for that relationship with the object which the collector considers paramount. The problem is that this relationship gets lost among the many considerations currently juggled by public art galleries.

"There as many types of collectors as there are collections," writes Rachel Campbell-Johnston, chair of Sotheby's UK, in her review of James Stourton's 2007 book, *Great Collectors of Our Time: Art Collecting Since 1945*.[16] But what many collectors today share, according to Stourton, is a growing awareness of wider social responsibility. To this I would add their increasing frustration over the separation of the collector from both the object and the institution, once a donation is completed. As a curator I was used to thinking that the donor need only be acknowledged as a credit line on the label of a work of art. I now recognize that a major collector – one such as Ken Thomson – whose specific object knowledge is unmatched, should continue to participate in the gallery's exhibition of the donated collection. A resurgence of confidence in art as a non-elitist and as the relevant focus of the public gallery needs to occur. Perhaps something like this underlies what Stourton identifies as the "public dimension" of collecting today.[17] In investing "their whole being – heart, mind and eye" the collector imagines, too, the public impact of a donation.[18] Ken certainly did, given his delight in looking at art with others. He seemed to picture himself as part of the gallery experience, interacting with the public. Nathalie Bondil, the Director of the Montreal Museum of Fine Arts, describes the greatest gift of collectors as "the joy of apprehending the world with one's eyes."[19] This sounds appropriate to Ken's purpose.

We all reveal much about ourselves in the way we arrange objects in space, especially in that place (our desk or our dresser) where we spend private time. Ken's corner office at the Thomson Building was his sanctuary. From his desk he had two views: the first was of Toronto's sculptural City Hall, designed by the Finnish architect Viljo Revell and completed in 1965. The second view was of the historic Canada Life office building, designed in 1929 by the Toronto architectural team Sproatt & Rolph and topped, in 1951, by a weather beacon still updated four times daily. A modestly sized and impeccable Automatiste painting by Paul-Émile Borduas (fig. 89), hanging straight across from where he sat, accompanied these sightlines to Toronto's skyline. As I scanned the room, from window to painting to

88
PAUL-ÉMILE BORDUAS
(1905–1960)
Bercement silencieux, 1956
Oil on canvas
113.7 × 145.6 cm

Beauty is the Eye Discovering

89
PAUL-ÉMILE BORDUAS
(1905–1960)
Abstract Composition, 1955
Oil on canvas
58.4 × 76.2 cm

window, between architectural and pictorial composition, I discovered a powerful visual play. The colour of City Hall's warm cement and the sandstone blocks of the Canada Life building were infused, in the painting, with dramatic but restrained accents of red and blue. The painting challenged our spatial perception, switching up proximity for distance. One's whole being was taken up in this play, which the constantly changing light of a passing weather pattern or the evening glow of an artificial light constantly recombined. Ken, it seems to me, was astutely sensitive to his surroundings and maximized the potential around his working space for contemplative visual exercise. On a more intimate scale, his arrangement of selected objects from his collection on and around his desk, especially smaller works best enjoyed when one is still, meant that every working moment was filled with compositional experiment. I caught a glimpse of the intimate relationships Ken imagined between objects; how he played images against one another to create new and unexpected meanings; how he marvelled at the artist's visual acuity.

"My paintings reveal what the mind, not the eye, sees. But painting, as you know quite well, is a feast for the eyes. If you combine these two thoughts, my world will emerge."[20] Painting's story, told by the Turkish writer Orhan Pamuk in his novel *My Name Is Red*, is a riddle. How can it be that "beauty is the eye discovering in our world what the mind already knows?"[21] The intensity of the relationship between us and things fascinated Ken. Art captures this relationship, makes it manifest. The study of art, therefore, is at its core the study how 'things' hold meaning. Pamuk's riddle asks the reader to consider the surface of the object as a mirror reflecting back, in the experience of beauty, the ontology of life. Such grand claims are notoriously difficult to argue and are impossible to use in defence of the relevance of the art gallery, but it is precisely what drove the British architect Sir John Soane to transform his house into his museum and live with and through the objects in his collection.[22] The intertwining of life and objects by Soane has been studied by the American art historian Donald Preziosi. He examines how objects define us, given that we live within the world of objects into which we are born, as individuals and as members of communities.[23] What Pamuk and Preziosi offer in rethinking the value of a collector such as Ken Thomson is a profound appreciation for how objects connect and orient us in the world. I am convinced that such an appreciation is not elitist.

"Who and what we are," writes Preziosi, "is linked inexorably to our where and when – which renders every thing we see and touch as intensely time-factored; marked by its age." Therefore, every object "is understood to bear within itself the legible traces of its time and place."[24] Things are records of time and place around and with which lives are lived. When the object profoundly connects us with this ontology it may be described as beautiful. In his effort to gain traction of this forever slippery adjective,

however, Preziosi switches "beautiful" for "funeous," a word he appropriates from the history of science. The historian of science and technology Cyril Stanley Smith defined funicity as the evidence of an object's creation held within the structure of its matter.[25] Preziosi isolates "the funicity of things" – their irresistible object-ness – as "the very bedrock of our socialization"[26] Objects are passports of time and place, and are the basis of a collective wealth of knowledge. As applied to the work of art, funicity adds a social dimension to object interpretation. The recognition of art's creation in the study of its materiality is a profound sort of object knowledge highlighting the maker, the artist's hand and humanity. Ken delighted in this contact with the person on the other side of the object.

Preziosi explains the social dimension of object knowledge, its funicity, by comparing it to our instinctual scanning and study of our surroundings. People, he notes, read dress and demeanour to understand the other person, just as they read the objects on desks and dressers.[27] "External prostheses" is his prickly phrasing for the way humanity navigates socially by interpreting visual cues and refining their object knowledge. I would add that the highest order of this prosthesis – or language – is art. Preziosi convincingly reveals the visual prosthesis of art to be the Esperanto of communication, the universally shared language of an expansive engagement with the object's multi-dimensional narrative potential. The art object is the most sophisticated of mirrors reflecting back, in the experience of beauty, the ontology of life.

Ken's collection of Canadian historical art began in the early 1950s with works by Cornelius Krieghoff, who painted intricate scenes of life (fig. 86) in the Province of Canada (as the combined provinces of Upper and Lower Canada – Ontario and Quebec – were known from 1841 to Confederation in 1867). Ken never lost his delight in Krieghoff's delicate touches of paint and luminous glazes through which one connects to another time and place. By 1969 Ken's collection had grown large enough to warrant the formation of the Thomson Works of Art Ltd., the holding company for the purchase and care of his collection, held in trust for his three children. Over the next three decades he focused primarily on leading historical Canadian artists – Krieghoff, Morrice (fig. 90), Tom Thomson (figs. 82, 83, 84), the Group of Seven (in particular MacDonald, Harris and Varley), David Milne and, nearer the end of his life, William Kurelek and Paul-Émile Borduas (figs. 88, 89). His choices were canonical, meaning he did not waver from that chronological list of artists whose paintings were fixed in the Canadian consciousness by English-Canadian critics and art historians. With Canada's centenary in 1967 the relationship of these artists to national identity had been cemented. Ken, in spite of working many years in the UK, was a proud Canadian. However, having accepted the established reputations of these artists as Canadian icons, he remained fascinated with the objects themselves, not their academic nor nationalist discourse.

Beauty is the Eye Discovering

90
JAMES WILSON MORRICE
(1865–1924)
Piazza del Campo, Siena, 1902
Oil on wood
15.4 × 12.2 cm

From 1925, when Newton McTavish published *Fine Arts in Canada*, to Fred Housser's *A Canadian Art Movement: The Story of the Group of Seven* of 1926, Graham McInnes's *A Short History of Canadian Art* of 1939 (revised and republished in 1950), William Colgate's *Canadian Art: Its Origin and Development* (1943), Donald Buchanan's *The Growth of Canadian Painting* (1950), J. Russell Harper's Canadian centenary project, *Painting in Canada: A History* (first published in 1966), and finally to Dennis Reid's *A Concise History of Canadian Painting* (first published in 1973), the story of art in Canada is told as an outgrowth of the British landscape aesthetic of the picturesque.[28] John O'Brian and Peter White's *Beyond Wilderness: The Group of Seven, Canadian Identity, and Contemporary Art*, published in 2007, reconsiders the entrenchment, in English Canada, of national cultural identity in wilderness landscape.[29] Its root in the first British topographers to survey lands annexed by the Empire flourished with the Group of Seven, who, during the 1920s, satisfied a desire to picture a distant place. The conflation of art and national identity is a point of great debate within Canadian art history. Another is the market for Canadian historical art – its growing strength and its canonical focus.

One of Ken's most public moments as a collector was his acquisition in 2001 of a major Group of Seven painting by Lawren Harris. *Baffin Island Mountains* (fig. 91) broke any previous auction sale record. The *Globe & Mail* reported the sale at Joyner Canadian Fine Art as setting a "world-record price for a Canadian painting"[30] Amidst consternation expressed by art historians that the market domination of Tom Thomson and the Group of Seven might be an elitist, ethnocentric hold-out of colonial Canada, sales of their work continue to lead the Canadian art market, piquing public imagination. These paintings form the backbone of Ken's collection of Canadian historical art and they resonate with contemporary relevance. Globalization, and shifting global populations, might mean that national cultural identity is less stable than it was over eighty years ago (when Tom Thomson and the Group were painting), but it was never less a production of narrative.[31] The object's multi-dimensional narrative potential means its reading is never fixed. What endures is its power to connect one viewer to another and to provide critical insight into the time and place in which we live. Ken, as I hope to conclude, delighted in this revelation with others.

Ken spent his life pursuing art treasures buried in private collections. When a deal was struck, he would ask for the object's story. "Meanwhile," Ken asked, regarding Cornelius Krieghoff's *Breaking up of a Country Ball in Canada, Early Morning* of 1857 (see fig. 14), which he acquired privately in 1975, "when the mood strikes you, I wonder if you would be good enough to gather as many facts about the history of the painting as possible, the lady who gave it back to you in the 30's, her residence in New York in the 1890's, etc. . . . I would like to put together as complete a story as possible." And, he added, "I would like this to be the beginning of a continuing friendship."[32] Collecting was his social passion. He delighted especially in

91
LAWREN STEWART HARRIS
(1885–1970)
Baffin Island Mountains, *c.* 1931
Oil on canvas
101.6 × 127.2 cm

92
A.Y. JACKSON
(1882–1974)
Red Barn, Petite Riviere, *C.* 1930
Oil on canvas
64.0 × 81.9 cm

connecting with the descendants of artists who had inherited the paintings he subsequently purchased. He fastidiously recorded the object's provenance, tracing if he could its movement back to the moment it left the artist's hands. This record of the movement of art from one owner to another was part of the object knowledge Ken favoured that formed, appropriately, "the bedrock of our socialization."[33]

In strictest confidence, as he would always insist in correspondence, he began a lively exchange of letters with A.Y. Jackson's niece, Naomi Jackson Groves. "It seems a long time," she wrote, "since our last rapid-fire exchange of letters. What fun it was!"[34] Following his acquisition in 1990 of her uncle's oil sketch, *Red Barn, Petite Riviere* (fig. 92), which Ken assured her he would carefully conserve and re-frame as a cherished possession, Groves responded: "Your beautiful letter which arrived yesterday confirmed my feeling that your visit here was just a perfect one. You bravely ploughed through the storm (we are tough Canucks) and we really had fun, like good friends, and covered lots of 'territory' The strange and nice thing: I don't 'miss' my red baby at all but am delighted with the fame it will get there with your collection."[35]

The Thomson Canadian wing at the AGO grants us all access to a major collection of Canadian historical art. When you walk through those spaces, consider Ken's fascination with each object. Remember the work of art connects us and its exhibition is always full of surprises. This public art gallery will be "a special place where people and art meet as never before."[36]

Beauty is the Eye Discovering

I would like to thank David Thomson for the opportunity to write this paper, Ash Prakash for his tremendous insight and guidance, and Conal Shields, Dennis Reid, Laszlo Cser and Geoffrey Joyner for sharing their memories of Ken Thomson. Finally, thank you Anastasia Apostolou for making so much information available to me.

1 Stephen E. Weil, 'Creampuffs and Hardball: Are You Really Worth What You Cost or Just Merely Worthwhile?', in *Reinventing the Museum: Historical and Contemporary Perspectives on the Paradigm Shift*, ed. Gail Anderson (Oxford: AltaMira Press, 2004), pp. 343–47.

2 http://portal.unesco.org/culture/en/ ev.php-URL_ID=15553&URL_DO=DO_ TOPIC&URL_SECTION=201.html.

3 Weil in Anderson 2004, p. 345.

4 Gail Anderson in Anderson 2004, p. 1.

5 *Ibid.*, p. 2.

6 As quoted by Robert Fulford from the brochure issued at the front desk of the gallery: Robert Fulford, 'Ken Thomson's strange, lonely gallery in downtown Toronto', *The National Post*, February 12, 2002; http://www.robertfulford.com /ThomsonGallery.html.

7 Nicolas Bourriaud, *Relational Aesthetics,* trans. Simon Pleasance and Fronza Woods (Paris: les presses du réel, 2002), p. 16.

8 Cheryl Meszaros, 'Interpretation in the Reign of "Whatever"', MUSE, xxv/1 (January/February 2007), p. 19.

9 Adam Gopnik, 'The Mindful Museum', *The Walrus* (June 2007), p. 90.

10 *Ibid.*, p. 90.

11 Jane Kallir, 'The problem with a collector-driven market', *The Art Newspaper*, July 12, 2007.

12 *Ibid.*

13 *Ibid.*

14 Edward Wyatt, 'To Have and Give Not: Greatness Beckons, but a Museum's Patron Stops Short of the Ultimate Gift. Now What?', *The New York Times*, February 10, 2008.

15 *Ibid.*

16 Rachel Campbell-Johnston, 'The Secrets of Successful Art Collectors', *The Times*, November 6, 2007.

17 James Stourton, *Great Collectors of Our Time: Art Collecting Since 1945* (London: Scala Publishers Ltd., 2007), p. 10.

18 *Ibid.*, p. 19.

19 Nathalie Bondil, 'Introduction', *All for Art! In Conversation with Collectors* (Montreal: The Montreal Museum of Fine Arts, 2007), p. 12.

20 Orhan Pamuk, *My Name Is Red*, translated from the Turkish by Erda M. Göknar (New York: Alfred A. Knopf, 2001), p. 281.

21 *Ibid.*

22 For Sir John Soane's Museum, see http://www.soane.org/.

23 Donald Preziosi, 'Hearing the Unsaid: Art history, museology, and the composition of the self', *Art History and its Institutions: Foundations of a Discipline*, ed. Elizabeth Mansfield (London: Routledge, 2002), p. 28.

24 *Ibid.*, p. 29.

25 "Biological organisms and human cultures arising therefrom," added Smith, "have a high density of funeous detail, indeed their very nature depends on the transfer of blocks of historically acquired pattern": Cyril Stanley Smith, 'Structural hierarchy in science, art and history', in *On Aesthetics in Science*, ed. Judith Wechsler, 2nd edn (Boston: Birkhäuser, 1988), p. 36.

26 Preziosi 2002, p. 30.

27 *Ibid.*, p. 36.

28 See Leslie Dawn, 'The Britishness of Canadian Art', in *Beyond Wilderness: The Group of Seven, Canadian Identity, and Contemporary Art*, ed. John O'Brian and Peter White (Montreal and Kingston: McGill-Queen's University Press, 2007), pp. 193–201.

29 See John O'Brian and Peter White, 'Introduction', *ibid.*, pp. 3–6.

30 Deirdre Kelly, 'Art World Buzzing as Harris Price Tops $2-million', *Globe & Mail*, May 30, 2001.

31 See Stuart Hall, 'Cultural Identity and Diaspora', in *Diaspora and Visual Culture: Representing Africans and Jews*, ed. Nicholas Mirzoeff (London: Routledge, 2000), p. 21.

32 Letter to Ken Thomson, Toronto, from Naomi Jackson Groves, Ottawa, July 18, 1991; PC0809, Thomson Works of Art Ltd., Toronto.

33 Preziosi 2002, p. 30.

34 Letter to Ken Thomson, Toronto, from Naomi Jackson Groves, Ottawa, January 30, 1990; PC0809, Thomson Works of Art Ltd., Toronto.

35 Letter, May 13, 1975; Thomson Works of Art Ltd., Toronto.

36 Matthew Teitelbaum, 'Transformation AGO Campaign', http://www.ago.net/ transformation/support.cfm.

A Gallery of Canadian Paintings

93
JAMES WILSON MORRICE
(1865–1924)
Nocturne, Venice
c. 1904–06
Oil on wood
12.3 × 15.3 cm

94
JAMES WILSON MORRICE
(1865–1924)
Nice, Côte d'Azur
c. 1912–14
Oil on wood
13.1 × 17.0 cm

95
JAMES WILSON MORRICE
(1865–1924)
The Promenade, Dieppe
c. 1910–11
Oil on canvas
60.2 × 73.0 cm

96
JAMES WILSON MORRICE
(1865–1924)
The Promenade, Dieppe
c. 1910–11
Oil on wood
12.3 × 15.4 cm

97
EMILY M. CARR
(1871–1945)
**Gitwangak, Queen Charlotte
Islands**, 1912
Oil on canvas
83.9 × 88.5 cm

98
EMILY M. CARR
(1871–1945)
Thunderbird, 1931
Oil on canvas
69.0 × 54.2 cm

99
DAVID B. MILNE
(1882–1953)
Sawmill at Dart's Camp, July 1921
Watercolour on paper
38.1 × 53.3 cm

100
DAVID B. MILNE
(1882–1953)
Ollie Matson's Yard, Winter, *c.* 1932
Oil on canvas
45.9 × 56.1 cm

101
DAVID B. MILNE
(1882–1953)
Maine Monument, *c.* 1913
Oil on canvas
51.1 × 56.3 cm

102
DAVID B. MILNE
(1882–1953)
Portrait of Mrs. Milne
(**Figure in a Guide Boat**), *c.* 1923
Watercolour on paper
38.1 × 51.1 cm

103
DAVID B. MILNE
(1882–1953)
The Time of Forest Fires, 1936
Oil on canvas
31.2 × 36.5 cm

104
DAVID B. MILNE
(1882–1953)
Village in the Sun II
September 1932
Oil on canvas
64.9 × 80.0 cm

105
DAVID B. MILNE
(1882–1953)
The Pump, 1929
Oil on canvas
31.3 × 41.6 cm

106
DAVID B. MILNE
(1882–1953)
Across the Garage, Palgrave, 1930
Oil on canvas
40.9 × 51.0 cm

107
DAVID B. MILNE
(1882–1953)
Still Life – Blue Bottle, 1931
Oil on canvas
50.8 × 56.5 cm

108
CLARENCE GAGNON
(1881–1942)
Dans la vallée de Baie Saint Paul,
Charlevoix, 1920
Oil on wood
11.7 × 18.0 cm

109
CLARENCE GAGNON
(1881–1942)
Une rue de Baie Saint Paul, 1923
Oil on wood
16.2 × 23.6 cm

110
CLARENCE GAGNON
(1881–1942)
Horse-racing in Winter, Quebec
undated
Oil on wood
22.2 × 28.2 cm

111
TOM THOMSON
(1877–1917)
Northern Lights, spring 1917
Oil on plywood
21.4 × 26.4 cm

112
TOM THOMSON
(1877–1917)
Moonlight, Algonquin Park
c. 1914–15
Oil on wood
21.7 × 26.9 cm

113
TOM THOMSON
(1877–1917)
The Poacher, 1915
Oil on wood
21.2 × 26.8 cm

114
TOM THOMSON
(1877–1917)
Autumn Woods, Algonquin Park
c. 1914–15
Oil on wood
21.2 × 26.6 cm

115
TOM THOMSON
(1877–1917)
The Red Maple, Algonquin Park
c. 1915
Oil on wood panel
22.0 × 27.2 cm

116
TOM THOMSON
(1877–1917)
Open Water, Joe Creek
undated
Oil on wood
21.5 × 26.75 cm

117
TOM THOMSON
(1877–1917)
Birch Grove, Algonquin Park
c. 1916
Oil on wood
22.0 × 27.0 cm

118
TOM THOMSON
(1877–1917)
The Log Jam, *c.* 1916
Oil on composite wood-pulp board
21.6 × 26.7 cm

119
TOM THOMSON
(1877–1917)
Ragged Rapids, undated
Oil on wood
21.4 × 26.7 cm

120
TOM THOMSON
(1877–1917)
The Dead Pine, undated
Oil on wood
26.7 × 21.4 cm

121
J.E.H. MacDonald
(1873–1932)
Winter, High Park, undated
Oil on composite wood-pulp board,
later mounted on corrugated
cardboard
12.5 × 10.8 cm

122
J.E.H. MacDONALD
(1873–1932)
Maple Boughs, Algoma, undated
Oil on composite wood-pulp board
21.5 × 26.5 cm

123
J.E.H. MacDONALD
(1873–1932)
Batchewana Rapids, undated
Oil on composite wood-pulp board
21.5 × 26.6 cm

124
J.E.H. MacDONALD
(1873–1932)
Tangled Bush, Algoma, 1919
Oil on paperboard
21.5 × 26.6 cm

125
J.E.H. MacDONALD
(1873–1932)
Algoma, 1920
Oil on wood-pulp board
21.4 × 26.4 cm

126

J.E.H. MacDONALD

(1873–1932)

Poplars and Rock, Sturgeon Bay

August 1931

Oil on paperboard

21.5 × 26.6 cm

127

J.E.H. MacDONALD

(1873–1932)

Round Rock, Tent Bay,

Bathsheba, Barbados, 1932

Oil on paperboard

21.4 × 26.8 cm

128
J.E.H. MacDONALD
(1873–1932)
Agawa Canyon, Algoma, undated
Oil on wood-pulp board
21.3 × 26.6 cm

129
J.E.H. MACDONALD
(1873–1932)
Stream in Algoma, *c.* 1919–20
Oil on wood-pulp board
26.9 × 35.2 cm

130
J.E.H. MACDONALD
(1873–1932)
Algoma Stream, 1920
Oil on panel
21.6 × 26.7 cm

131
LAWREN STEWART HARRIS
(1885–1970)
Trees and Snow, 1924
Oil on panel
26 × 35.6 cm

132
LAWREN STEWART HARRIS
(1885–1970)
Snow, Algonquin Park, *c.* 1916–17
Oil on canvas
46.0 × 51.6 cm

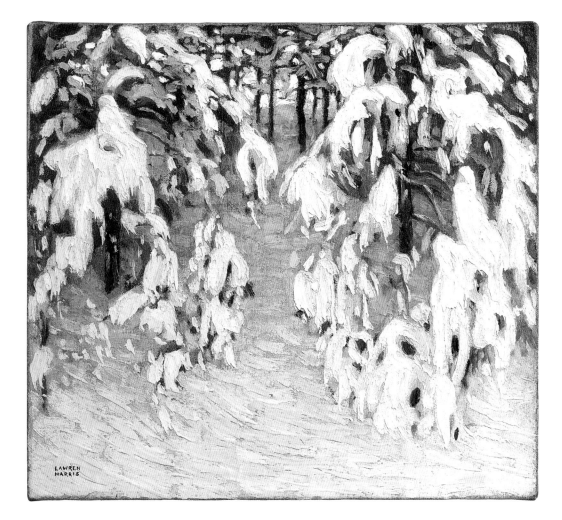

133
LAWREN STEWART HARRIS
(1885–1970)
**North Greenland Coast,
Arctic Sketch XXV**, 1930
Oil on paperboard
30.4 × 38.0 cm

134
LAWREN STEWART HARRIS
(1885–1970)
Lake Superior, c. 1922
Oil on paperboard
30.2 × 37.6 cm

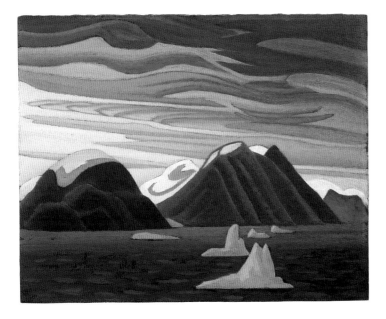

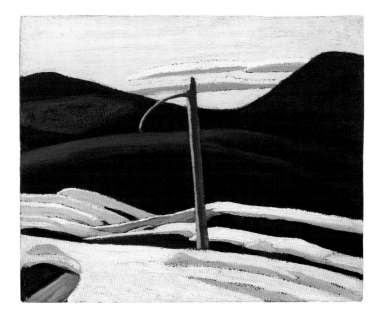

135
FREDERICK VARLEY
(1881–1969)
Upper Lynn Valley, Vancouver
c. 1933
Oil on wood
30.5 × 38.1 cm

136
FREDERICK VARLEY
(1881–1969)
**Sunrise, Sphinx Glacier,
Garibaldi Park**, undated
Oil on wood
30.4 × 37.7 cm

137
FREDERICK VARLEY
(1881–1969)
Lake Shore with Figure
(**Rocky Shore**), 1922–23
Oil on canvas
100.3 × 69.8 cm

138
A.Y. JACKSON
(1882–1974)
The Red Barn, c. 1930
Pencil on paper
20.3 × 26.7 cm

139
A.Y. JACKSON
(1882–1974)
The Red Barn, c. 1930
Oil on wood
21.1 × 26.6 cm

140
A.Y. JACKSON
(1882–1974)
The Red Barn, *C.* 1930
Oil on canvas
64.0 × 81.8 cm

141
A.Y. JACKSON
(1882–1974)
**Road to Charlevoix, near Baie
Saint Paul**
undated
Oil on wood
21.3 × 26.7 cm

142
A.Y. JACKSON
(1882–1974)
Street in Murray Bay, c. 1929
Oil on wood
21.5 × 26.7 cm

143
A.Y. JACKSON
(1882–1974)
The Stream, Sainte Tite des Caps
C. 1934
Oil on canvas
53.6 × 66.2 cm

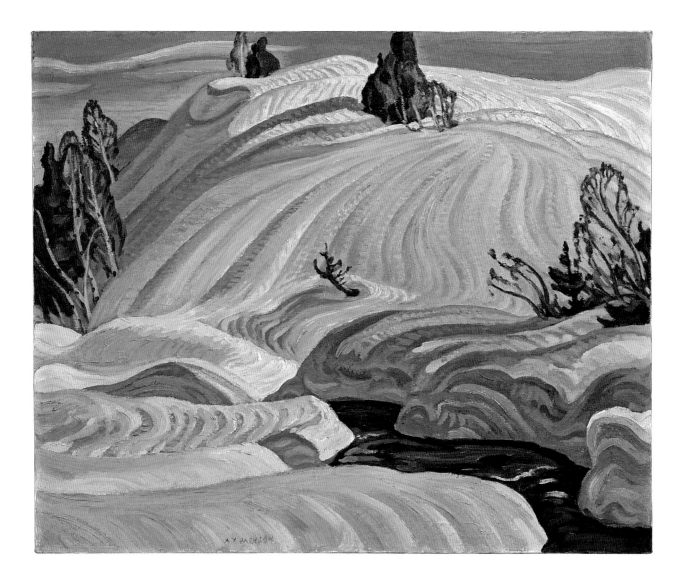

144
A.Y. JACKSON
(1882–1974)
Quebec from Levis, undated
Oil on wood
21.6 × 26.7 cm

145
A.Y. JACKSON
(1882–1974)
Kispiox, B.C., 1927
Oil on wood
21.4 × 26.6 cm

146
A.Y. JACKSON
(1882–1974)
Yellowknife Country, 1929
Oil on canvas
81.8 × 101.8 cm

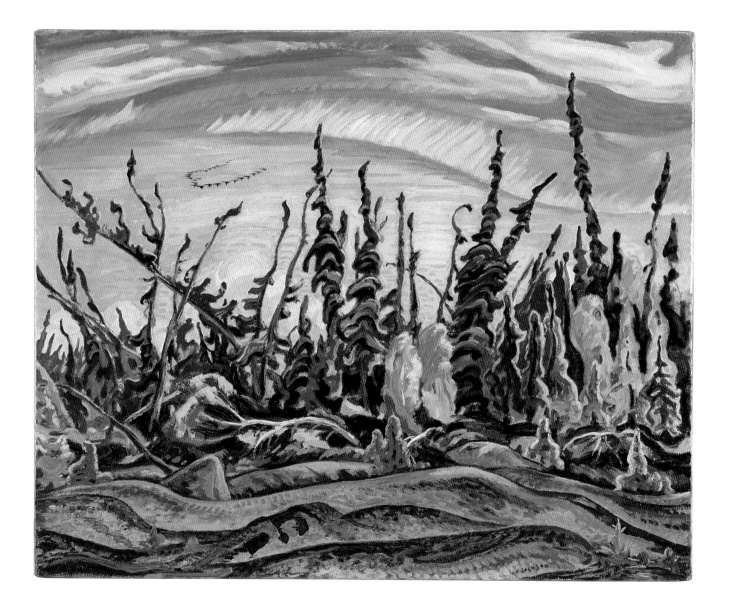

147
ARTHUR LISMER
(1885–1969)
A Clear Winter, undated
Oil on canvas
91.4 × 76.2 cm

148
ARTHUR LISMER
(1885–1969)
**Sumach and Maple,
Huntsville**, 1915
Oil on canvas
126.9 × 101.2 cm

149
ARTHUR LISMER
(1885–1969)
Little Island, MacGregor Bay, 1930
Oil on wood-pulp board
32.9 × 40.0 cm

150
ARTHUR LISMER
(1885–1969)
**Logging, Nova Scotia,
near Bedford**, 1917–18
Oil on wood-pulp board
30.7 × 40.5 cm

151
ARTHUR LISMER
(1885–1969)
Logging in Nova Scotia
1920
Oil on canvas
91.4 × 101.5 cm

152
FRANKLIN H. CARMICHAEL
(1890–1945)
Thornhill, 1918
Oil on wood-pulp board
25.2 × 30.5 cm

153
FRANKLIN H. CARMICHAEL
(1890–1945)
Wild Cherry Blossoms
undated
Oil on paperboard
25.3 × 30.4 cm

154
FRANKLIN H. CARMICHAEL
(1890–1945)
Festive Autumn, 1921
Oil on canvas
76.4 × 91.7 cm

155
FRANKLIN H. CARMICHAEL
(1890–1945)
Frood Lake, 1936
Oil on paperboard
25.2 × 30.3 cm

156
FRANKLIN H. CARMICHAEL
(1890–1945)
Cranberry Lake, 1931
Oil on canvas
76.7 × 92.0 cm

157
FRANKLIN H. CARMICHAEL
(1890–1945)
Lake Superior, *c.* 1930
Oil on multi-ply board
25.1 × 30.3 cm

158
FRANKLIN H. CARMICHAEL
(1890–1945)
In the La Cloche Hills, 1939
Oil on wood
25.35 × 30.5 cm

159
FRANKLIN H. CARMICHAEL
(1890–1945)
Autumn Splendour, undated
Oil on wood-pulp board
30.3 × 24.7 cm

160
ALFRED JOSEPH CASSON
(1898–1992)
Rosseau, Muskoka, 1920
Oil on paperboard
23.4 × 28.6 cm

161
ALFRED JOSEPH CASSON
(1898–1992)
**Burnt-over Ground, Coldwell,
Lake Superior**, 1928
Oil on multi-ply board
23.8 × 28.3 cm

162
ALFRED JOSEPH CASSON
(1898–1992)
House-tops in the Ward, *c.* 1924
Oil on canvas
114.3 × 94 cm

163
WILLIAM KURELEK
(1927–1977)
Prairie Town in Winter, 1966
Mixed media on hardboard
93.0 × 124.7 cm

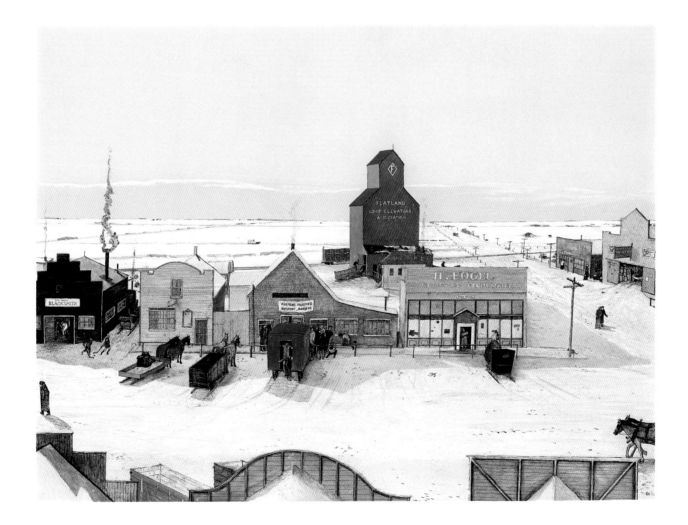

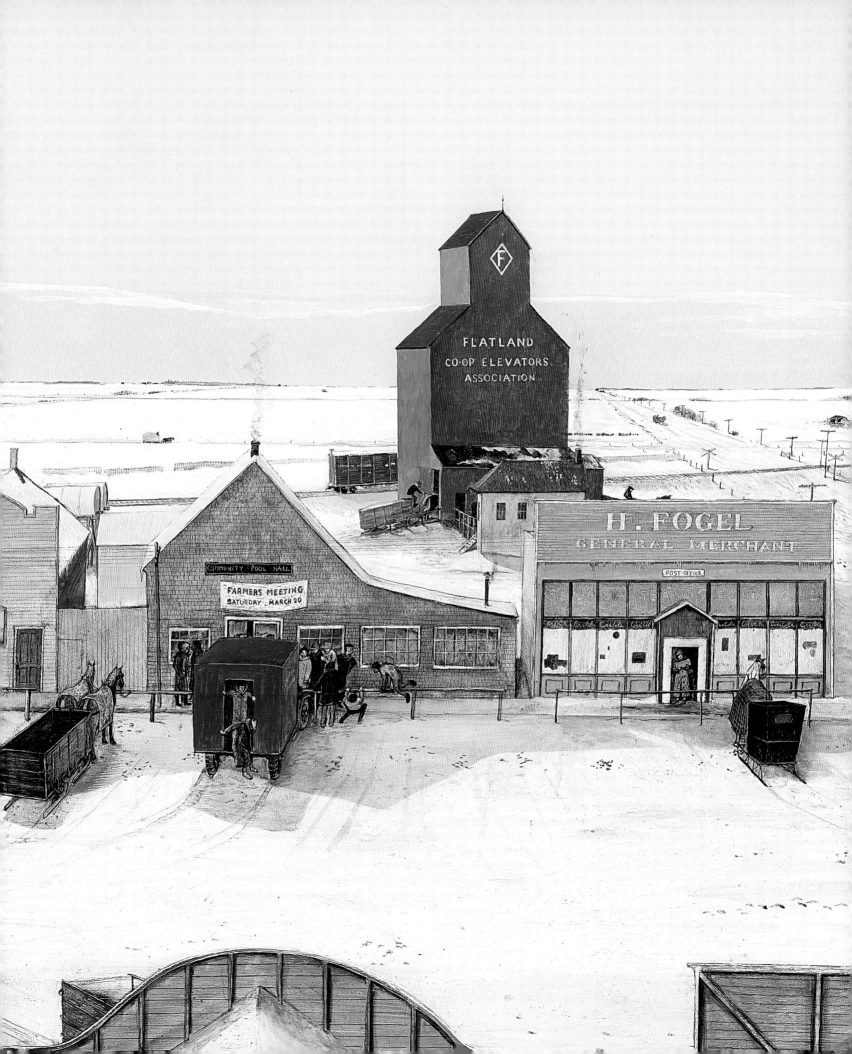

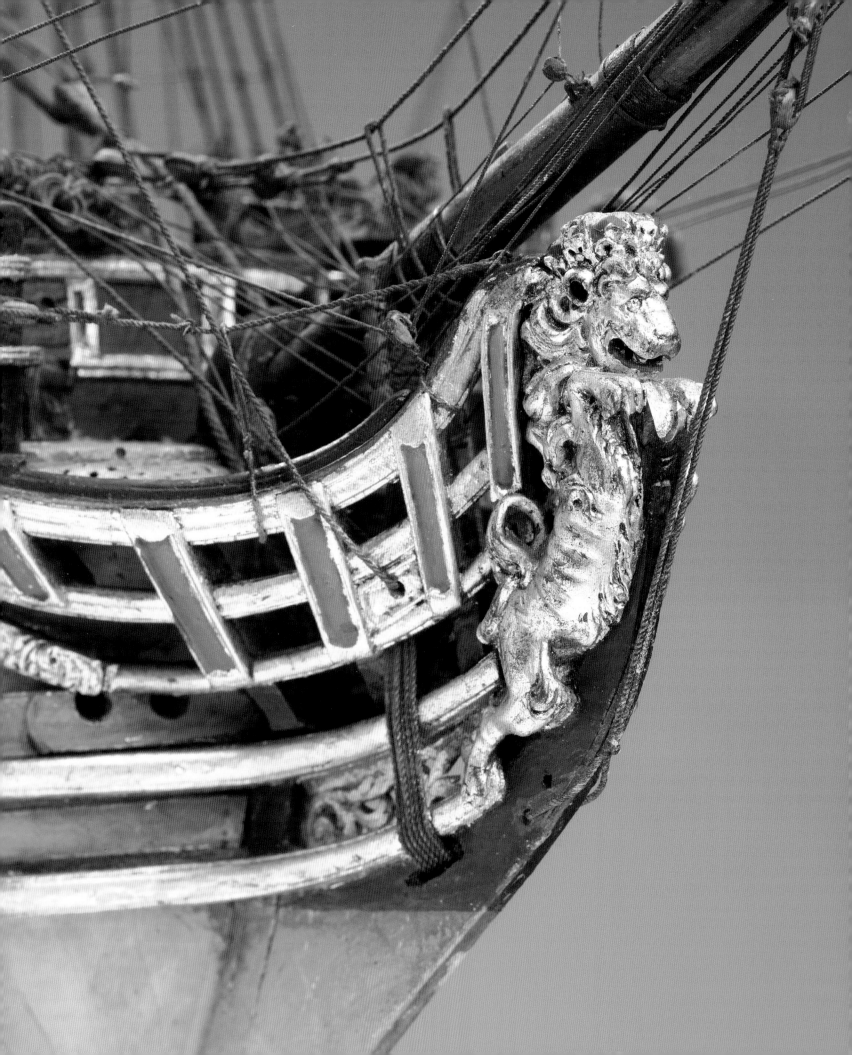

Ken Thomson, Collector of Ship Models

SIMON STEPHENS

Curator, Ship Model and Boat Collections,
The National Maritime Museum, Greenwich, London

The collecting of ship models can be traced back to the early seventeenth century. Notable collectors included Samuel Pepys, King Charles I, King George III and, clearly, the ship model would have inspired and influenced the thinking of these and other important figures. In particular Samuel Pepys, Secretary to the Navy Board and famous diarist, was moved to write on August 11, 1662: "Mr Deane, the assistant [shipwright] at Woolwich came to me He promises me also a model of a ship, which will please me exceedingly, for I do want one of my owne."

This is exactly one of the many aspects of these historical works of art that would have excited Ken. To know that some of these models once formed the centre of a very important discussion between high-ranking civil servants and naval officers, as well as convincing the king to encourage Parliament to pay for the Navy, must have had a fascination for Ken, as it certainly does for me. I liken it to reading a document signed by a very important dignitary and knowing that it once passed through their hands. Latterly, large and impressive builder's models of British warships and merchantmen were made as marketing tools as well as for use during the design and concept stage. Again, these models would have influenced the decision whether the British Government or foreign navies should place an order with British shipyards – worth hundreds of thousands of pounds – or encourage shipowners to buy the latest design for transporting passengers and cargo around the world profitably.

It was probably Ken's interest in fine carvings and sculpture that eventually aroused his interest in ship models. I suggest that one link was carved ivory and animal bone, which would fit comfortably with the bone models made by French prisoners of war in Britain during the Napoleonic Wars. Judging by the acquisition records, it was these models that set him on his way into the world of ship models. Not only did he find the various materials and their application of interest, but the models also had an intriguing human story, which was another passion of his. These fascinating models illustrate the sheer ingenuity of the French sailors, who produced objects in difficult conditions with limited materials and tools, eventually to sell them at the local prison open days and markets.

Surveying the models that Ken collected during the early years, one finds that they consist of the bone and wooden POW's work as well as the more common builder's models. This is not surprising, as it is these types of model, occasionally interspersed by the rare seventeenth- and eighteenth-century warship models, that were the bread and butter of most of the marine auctions over the last twenty to thirty years. Another very important criterion, evidently, was quality. This varied with the early examples but, as the collection grew, the quality improved, especially among the wooden and bone models. Acquisition of the collection also depended upon availability and the strength of the antiques market. It is a credit to Ken and his close circle of advisers, Laurie Langford and Michael

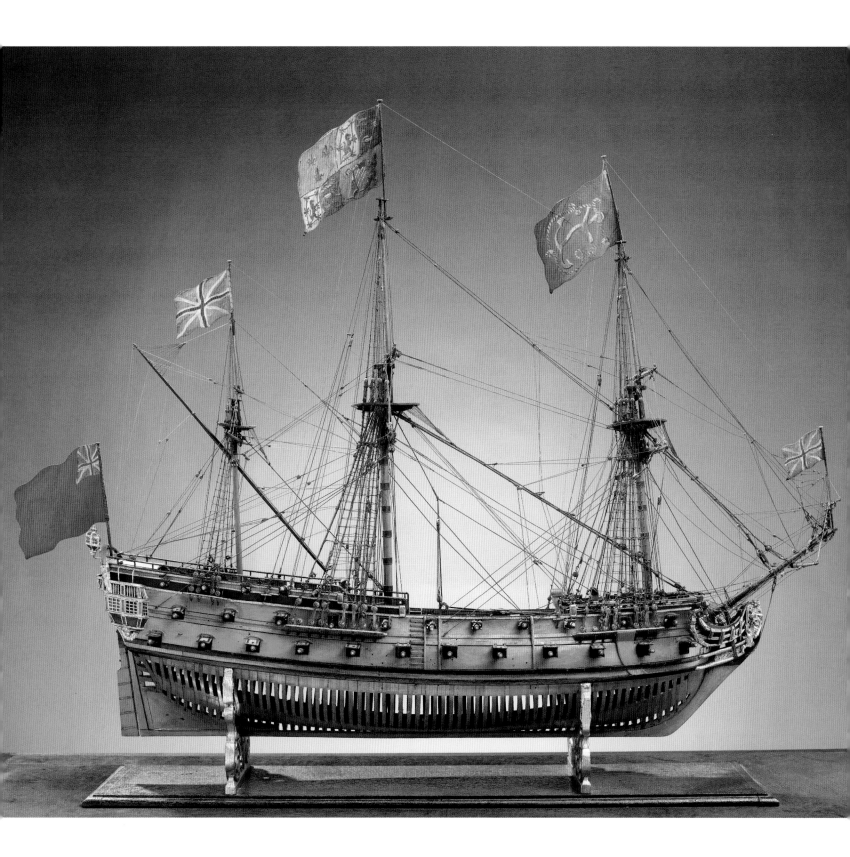

Turner in particular, that the collection has enough scope and quality to illustrate in some depth the design and development of the ship model over the last three hundred years.

It is a well-known fact that collectors of ship models have a fascination for the miniaturization of the various vessels depicted. Being able to explore the construction, design, layout, workings and living spaces, together with the human interaction entailed, all within a small area in front of you, can be very rewarding. Collectors also find their objects to be a convenient way of breaking the ice in conversation, or as conversation subjects in themselves. One of the great attractions of ship models is that they appeal to all ages and to both sexes, and all sorts of connections or correlations can come out of conversation within a family group.

The Collection further includes examples of the many 'styles' of model-making, which have parallels with artists and their paintings. Generally, experts, curators and auctioneers have sought to identify the period of construction and the function for which the models were originally intended. The earliest examples known are so-called 'Navy Board' models (figs. 164, 165), of which the most noticeable feature is the partially planked hull, showing only the exposed frame below the level of the waterline. One of the rationales of this method of construction was to 'show off the lines' of the hull shape through the light and dark contrast between wood and shadow. The partially unplanked decks also allowed light into the model to show the design and layout of the many internal features such as the positions of the guns, the location and sizes of the cabins for the officers, and cooking equipment. It was thought that these elaborate and

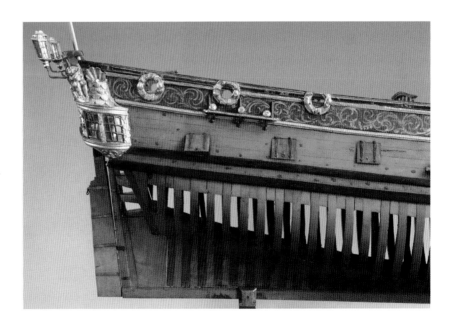

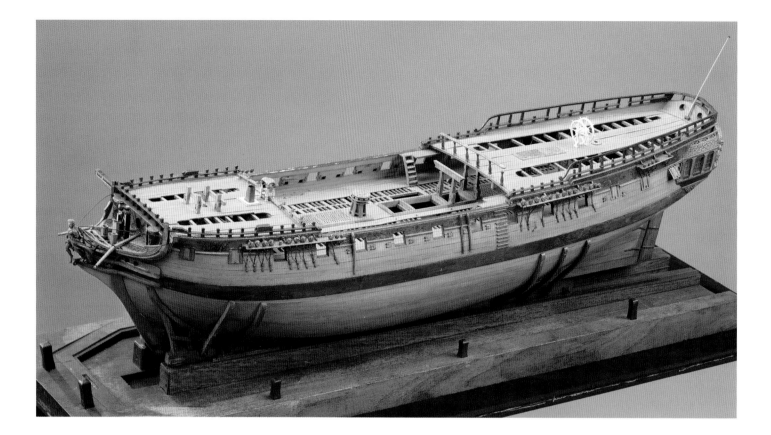

166
British 32-gun frigate
'Georgian' model
Britain, 1757
Boxwood

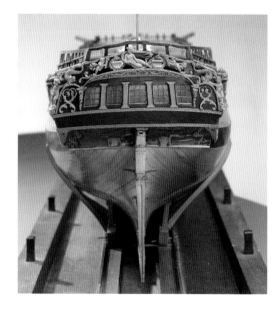

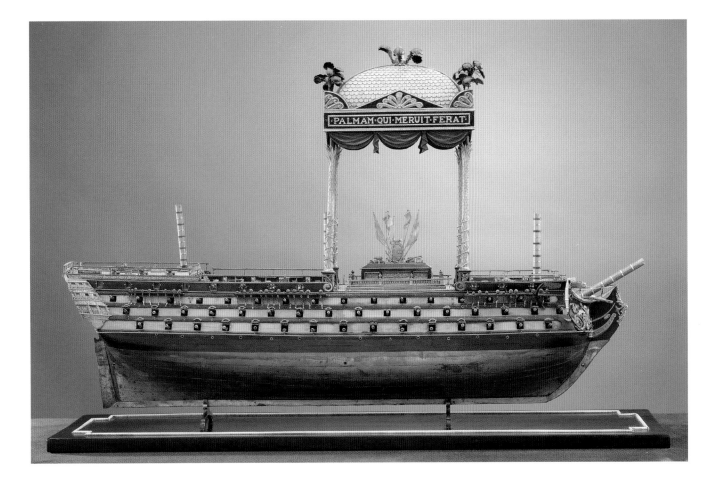

PALMAM·QUI·MERUIT·FERAT

167
**British three-decker 100-gun
warship, *Victory***
**Funeral souvenir of
Vice-Admiral Nelson**
Prisoner of War model
Britain (French craftsman), *c.* 1806
Fruitwood, boxwood, ebony, copper

highly decorated models were used for discussion by the Navy Board, the department in the British Navy responsible for the day-to-day running of the dockyards and the design and building of warships. The more likely reason for their construction, however, was either to achieve political influence or as the keepsakes of high-ranking naval officers and civil servants who had a personal connection with a particular ship.

As we move into the eighteenth century, the style and finish of the models bear a closer resemblance to the ships themselves, as the hulls are fully planked and mostly finished and decorated like the full-sized vessels (fig. 166). In this style, known as 'Georgian,' another distinctive feature is that they were sometimes rigged with masts and spars to illustrate the major innovations introduced during the period. The POW models, already mentioned, constitute another, larger group within the Collection. There are over thirty of them, and they range from the larger bone and wooden examples down to the small and intricately made 'wood chip' models (figs. 167, 174). It is astonishing to note that all these models were

168
Warship
Prisoner of War model
Britain (French craftsman), *c.* 1795–1815
Bone

probably made without reference to a scaled ship's plan; their makers relied solely upon their memory to produce these desirable objects. It is not surprising to see that in some of these the proportions of the hull and the height and rake of the masts are exaggerated. A clever marketing ploy used by the prisoners was to label the model with the names of famous ships that had taken part in recent sea-battles, even though they did not often represent them accurately and they would include both British and French features in the same model. Another well-known feature of the POW model was making guns that could be pushed into the hull to simulate loading, then, on pulling a pair of rope cords hanging from the stern, would 'pop out' to the firing position.

A fairly large part of the collection comprises 'builder's models,' a style which started to appear during the mid nineteenth century (fig. 169). A great quantity of such models were made and they are still readily available today; on average, up to five will figure at any marine auction. Their most noticeable feature is the finishing of most of the metal fittings – such as propellers, anchors, guns and winches – in either gold

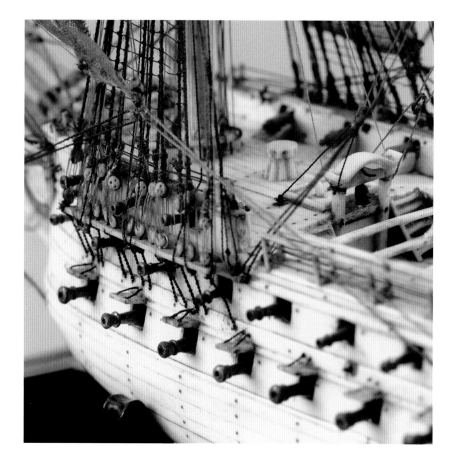

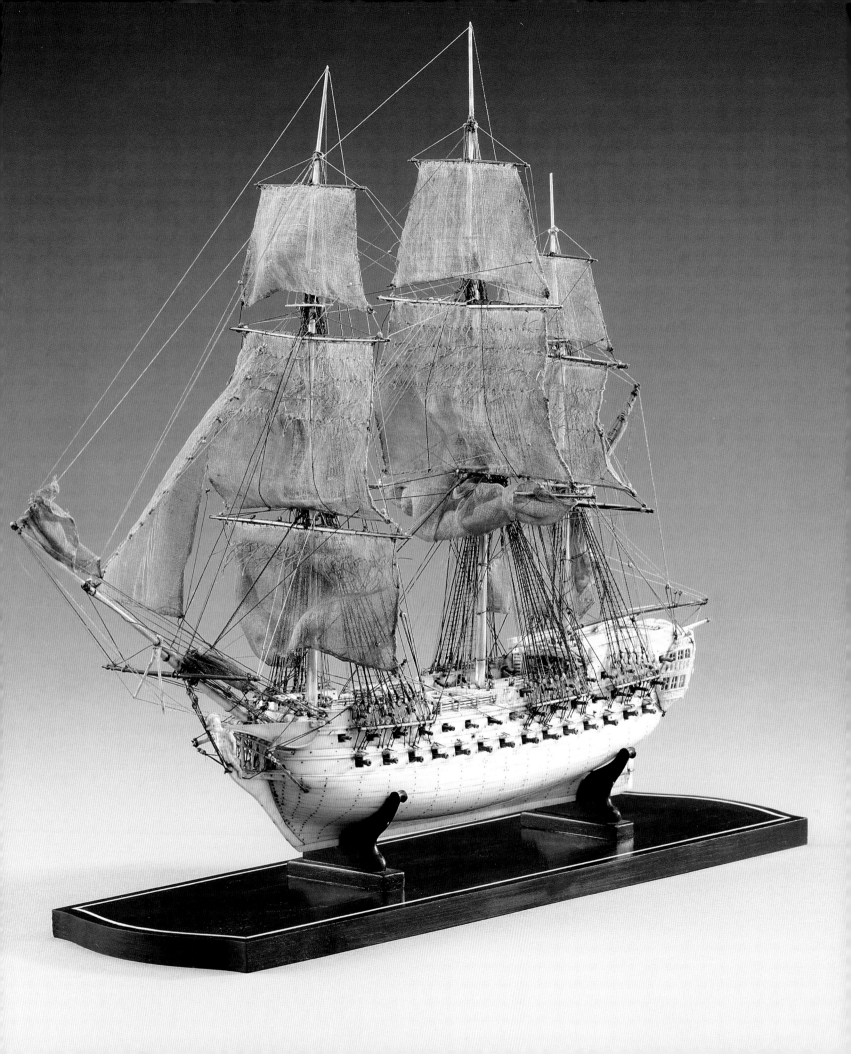

169
Turkish ferry steamer,
Bosphorus
Builder's model
Britain, 1921
Wood, metal

170
British armed motor
launch, Mimi
Builder's model
Britain, 1915
Wood, metal

or silver plate. This was not the case on the full-size vessels in reality, but was an important part of the models' role in catching the eye of a perspective buyer of either merchant or war ships at the many international trade fairs. Such models came in several formats – full hull, half hull, blocks – and, towards the late nineteenth century, some half-models were even mounted on surface-silvered mirrors which reflected a full-hulled version, enabling it to be displayed on a wall or on a shelf where space was at a premium. Most of these builder's models were produced in the shipyards, though there were a handful of professional model-making companies. Primarily used for advertising the yard's designs, they could also indicate the nature of a shipowner's fleet – the cargo carried, the destinations carried to – as well as serve a role as in the

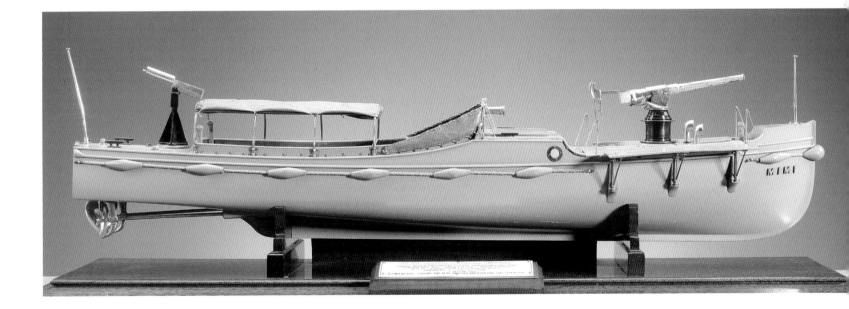

171
DONALD MCNARRY
British royal yacht, *Britannia* (1893)
Britain, 20th century
Wood

marine insurance and brokerage industries. Many of these models represent ships that had interesting and varied careers. These stories of man's constant endeavour with the sea were one of the attractions of these objects that engaged Ken, who had a passion for history and always sought the human interest.

Another small but notable group in the collection is that of miniature models by the living artist Donald McNarry (fig. 171). These take model-making to another level, as he has been able to reproduce a complex subject down to several inches in size and in some cases mount his models in a realistic seabase, combining a highly skilled craftsmanship with artistic interpretation. Again, this must have appealed to Ken's love for art, sculpture and miniaturization.

The collection includes a great variety of vessel types, ranging from sailing and powered warships right down to smaller craft such as fishing vessels, launches (fig. 170), lifeboats and ship's boats. The mercantile marine is well represented with all sorts of passenger and cargo ships, including ferries, tugs and excursion steamers. There is an international flavour to the collection, which includes models of French, Belgian, German, Argentinian and Japanese vessels. These models sometimes reflect a slightly different style and finish to the British examples.

Ken obviously had an interest in the different uses of materials and in the warmth and feel of wood, ivory and bone – a common thread running throughout his vast and diverse collection. In particular the Navy Board and Georgian models display a wealth of carved, gilded and painted decoration, exemplifying the quality of craftsmanship that he loved.

172
GEORGE STOCKWELL
**British two-decker 50-gun warship,
Bristol, detail of figurehead**
'Georgian' model
Britain, 1774
Boxwood, ivory, glass

173
Troop landing craft
'Georgian' model
Britain, *c.* 1755–60
Wood, brass, putty/plaster(?)

I am sure that Ken must have often pondered on the individual craftsmen who produced these amazing works of art. Who were they? How did they operate? This is answered to some degree by the extremely important model of the *Bristol* (see figs. 10, 172). Unlike other artists of the period and later, who often signed and dated their work, model-makers of the seventeenth and eighteenth centuries are generally anonymous and unidentified. However, there had been found by chance inside a model similar to the *Bristol* a folded note giving information about the ship and the model-maker, and, thinking that the *Bristol* might be by the same hand, I and others organized the internal exploration of its hull with a medical endoscope: in this way we were able to locate and then extract a rolled note signed and dated by the same maker, a Mr. George Stockwell of Sheerness, England (see fig. 11). The discovery of these notes and sometimes signatures inside other models again has enabled scholars and curators to research the individual craftsmen and to build a picture of how and where these models were produced. Again, this is something that would have enthralled Ken, as is borne out in his correspondence regarding this and other models.

Ken had some favourites, in particular the model of a landing craft (fig. 173). This is an exquisite model, built plank on frame, and is complete with the carved figures of both marines and ship's crew, with the oars rigged. This not only represents the introduction of amphibious

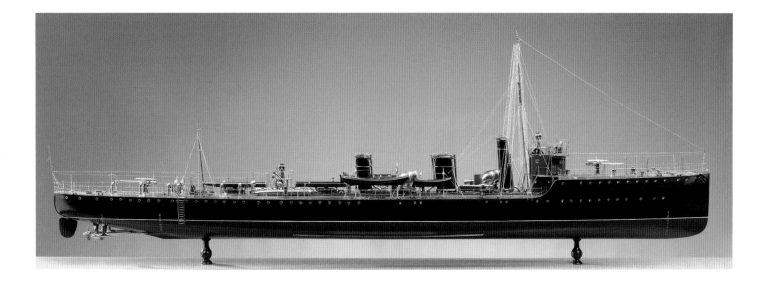

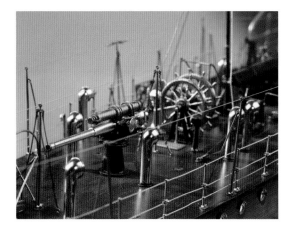

warfare to the British Navy but also brings very directly a strong human association to the model collection. The detail is such that not only does it give you an excellent idea of scale, but you can also study both the facial expressions and the uniforms of the figures and the seamanship of the manning and operating of these small craft. Other favourites of Ken included the torpedo-boat destroyer HMS *Hope* (fig. 174). The model shows off the graceful lines of this high-speed ship and is bristling with armament and numerous fittings, all finished to a high degree and gold-plated. Besides this aspect of the model, it is clear from his correspondence that Ken was also intrigued by its provenance and the trail of information relating to its past ownership and its relationship with individuals as well as the ship it represented.

This can be no more than a brief overview of what may be regarded in both breadth and content as one of the finest ship-model collections in private hands. Installed in the Art Gallery of Ontario, it will rival the collections of major maritime museums around the world.

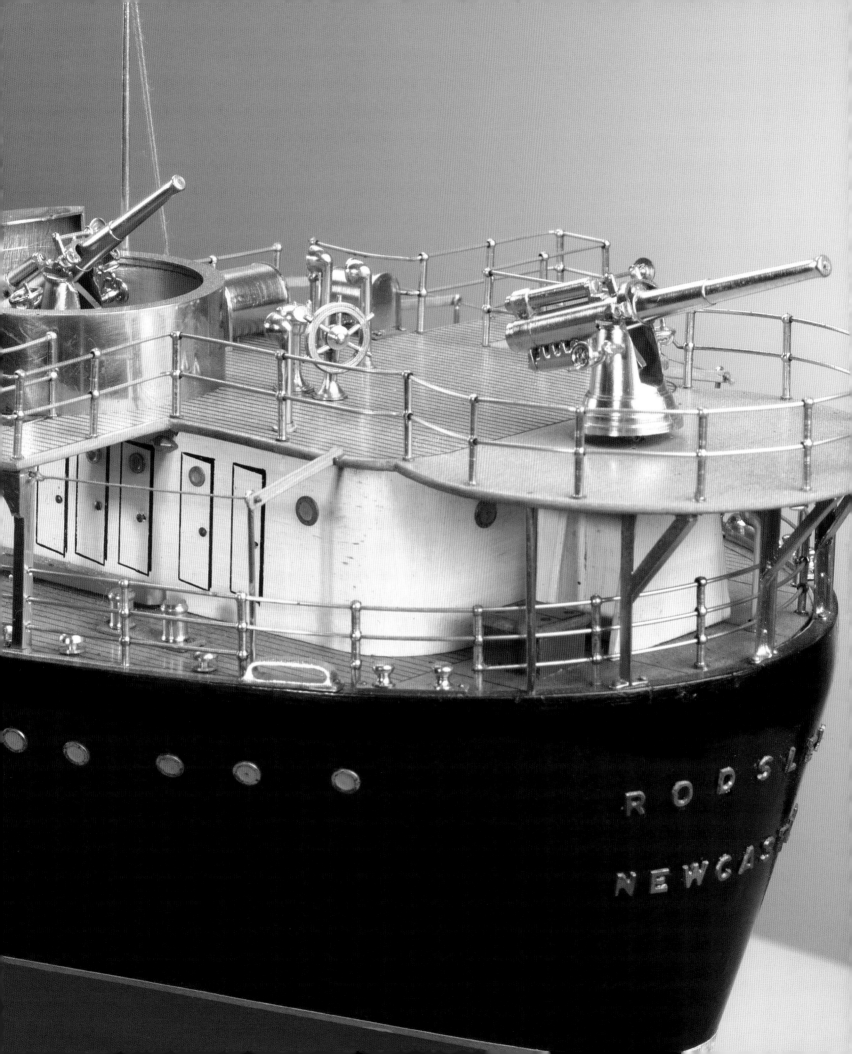

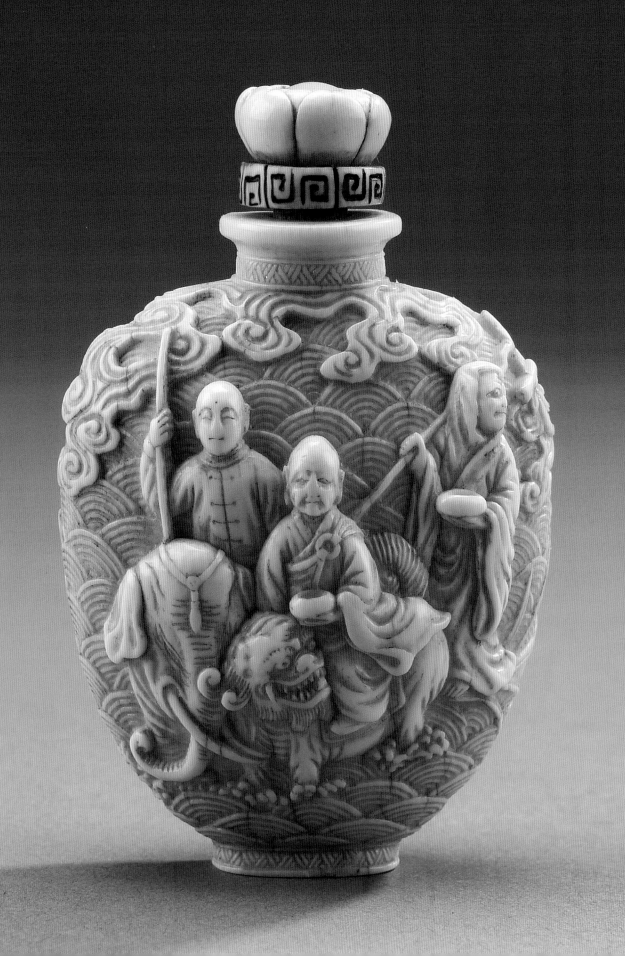

Ken Thomson, Collector of Chinese Snuff Bottles

ROBERT HALL

In an Art Gallery of Ontario magazine article ten years ago, Ken described the moment of his epiphany as a collector of antiques in a small shop in Bournemouth in 1953. He had happened upon two miniature ivory busts – beautifully made, about three inches high, on marble bases. They were tiny replicas of large Victorian busts but, in his hands, were more exquisite than the originals. He was greatly excited. When he had established that they were for sale, he did what Ken did very well and haggled, securing them for £24. From then on, he spent every spare moment walking the streets of London, searching for small carvings and sculptures that he could hold in his hand.

He explained his partiality for one object over another: "It is feeling and it is touch. When you find something that you love, you must touch it and hold it. That way you are getting as close to the person who made it as you will ever get. And when you get that close to something, when you feel it, when you look at it, if your heart is beating, you know it was made for you."

He said that these objects opened up a wonderful new world he never knew existed, and prompted him to explore the British Museum and the Victoria and Albert Museum. Ken had not grown up with art – he used to say rather that his father was a collector of businesses – but Roy Thomson's trust in his son, and support of his judgement, enabled him to pursue his new hobby with confidence, even though he did not retain many of his earliest purchases because, inevitably, his taste and eye became more refined.

I was fortunate enough to have been recommended to Ken as an expert in the field of Chinese snuff bottles, and so it was that Ken and I embarked upon a journey of discovery in the appreciation of these small objects. What struck me from the beginning was that he truly was a rather shy and humble man. One would never have dreamt of the magnitude of his power. When we were looking at snuff bottles, his manner was more that of a naughty schoolboy who had found some wonderful toys, whose enthusiasm was infectious, and who was going away to play with them.

Already in Ken's very modestly sized collection when I met him there was a wonderful Imperial ivory snuff bottle (fig. 176) with an incised Qianlong mark on the base. He had bought it in a Sotheby's sale in the 1980s. I could see how this truly beautiful bottle, with its soft buttery feeling of old ivory, would have satisfied Ken's passion for figures and minute detail. The majority of these old and coveted ivories develop a fine patina precisely because they were made to be handled and passed around for close inspection; their quality was therefore under higher scrutiny than that of many larger works of art intended for decoration. Their fortunate owners would keep them in their hands, fondling them and taking pleasure from the tactile qualities of their material.

176
Snuff bottle carved with three Daoist Immortals
Base incised with
Qianlong mark
(1736–95)
Ivory
76 × 51 × 25 mm

177
Jar for snuff
Late 18th century or early
19th century
Glass, original cloth seal
135 × 57 × 42 mm

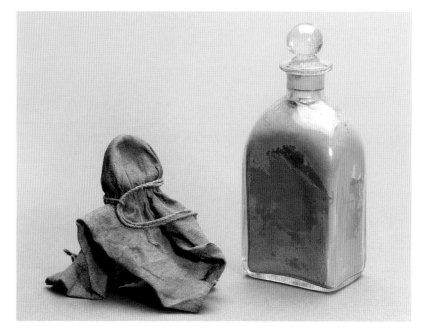

Chinese snuff bottles, and the powdered tobacco which they contained, were at the heart of a fashion that has no equivalent in China's long history. Because of the extraordinary variety of styles, techniques and materials found in these small objects, and the exquisite craftsmanship that was lavished upon them, these miniature masterpieces are one of the most important representations of the applied arts during the Qing dynasty.

Tobacco, introduced into China from Europe towards the end of the sixteenth century, was at first smoked in pipes. Its use as snuff began only after the establishment of the Qing dynasty in 1644. At that time smoking of tobacco was forbidden but, paradoxically, the use of snuff was acceptable because it was valued for its medicinal qualities (it was believed to cure colds, headaches, stomach disorders and many other illnesses). The powdered tobacco was dispensed in bottles, as were most other medicines in China, rather than in boxes, as was the European custom. The Chinese purchased their snuff 'in bulk,' so to speak, in large bottles (fig. 177). The tobacco was then transferred to small personal bottles by means of a special funnel, also usually made of ivory.

At first confined to the elite of the new dynastic house, the use of snuff and snuff bottles was widely established in and around the court at Beijing by the end of the seventeenth century. The use of snuff became a social ritual of the upper classes in Beijing, to which it appears to have remained limited for most of the eighteenth century. There, much art, taste and money were expended on these containers, which became

Snuff bottle
Qianlong period, 1736-95
Glass, imperial yellow, central band
carved with formalized archaic dragons,
between a frieze of decorative scrolls
and lappets, the shoulders with mask
and ring handles
59 × 41 × *c.* 28 mm
(67 mm with stopper)

objects of active acquisition. Indeed, snuff bottles became a new currency for the purchase of favours, positions and advancement in government, as well as a means of expressing good wishes to candidates in the Civil Service examinations and to aspirants for military positions.

Spreading slowly and gradually to the rest of the country, snuff-taking and the collecting of snuff bottles had become a habit adopted nationwide and among all social classes by the beginning of the nineteenth century. It was a common courtesy to offer friends a pinch of snuff upon meeting them in the street or at home, and great status accrued to the owner of an unusual or finely made bottle.

Made in every material known to the Chinese – glass, porcelain, jade and other hard stones, ivory, coral, lacquer, amber, wood – snuff bottles were then produced in enormous quantities of varying quality to supply the increased demand. Although the high point in the manufacture of most types of bottles was the eighteenth century, a great many fine bottles continued to be made throughout the nineteenth.

The popularity of snuff and snuff bottles rose and fell with the Qing dynasty. After the revolution and the establishment of the Republic in 1912, the fashion of snuffing died away. Today, however, the number of collectors throughout the world who are fascinated by these small, exquisite objects and attracted by their aesthetic and tactile qualities is rapidly growing.

Ken's collection also contained an excellent imperial yellow glass bottle (fig. 178) from the Qianlong period (1736–95). During the Ming (1368–1644) and Qing (1644–1912) dynasties, yellow was a colour reserved solely for Imperial use: ordinary citizens were barred from wearing or using anything yellow. There was no standard shade of yellow prescribed; Imperial objects exist in many different tones, ranging from pale lemon-yellow to rich egg-yolk yellow. Not content with this first Imperial yellow bottle, Ken added several more, and the group became one of his favourites. I think it was the tradition that he loved: the idea of the colour being reserved exclusively for the use of the Emperor really tickled him.

After our first meeting, Ken would sweep in about three times a year, excited and anxious to see what we had set aside for him. He carefully examined every tiny detail of each bottle and extracted every possible snippet of information from me.

We would sit there in my gallery fondling the bottles, twisting and turning them, trying to discover everything imaginable, whether it made sense or not. Ken's eyes would trace small areas of pigmentation, or discolouration, and even focus on firing blemishes, wanting to know still more. His imagination was strong, and at these times he was seemingly taken all the way back to the workbench of the artist or carver. He fell into a different world when he was studying bottles.

The bottles that Ken purchased were those that, in his hands, connected him with their makers and the spirit of their creation. He did not always

179
**Snuff bottle carved with Meng
Haoran** (689–740) and his attendant
seeking prunus blossom, the other side
with three figures amongst rocks and
trees, *c.* 1780–1850
Amber
59 × 51 × *c.* 28 mm
(71 mm with stopper)

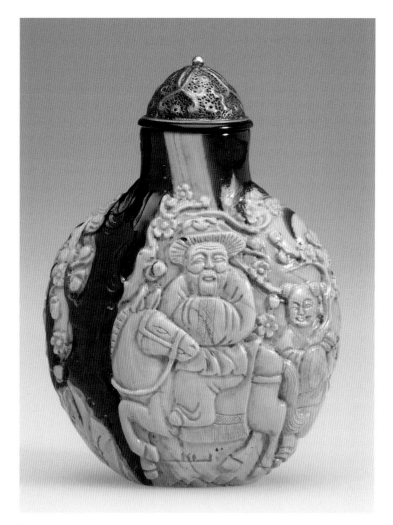

180
Snuff bottle
c. 1750–1850
Amber, bright orange with translucent areas, the body undecorated
66 × 51 × *c.* 23 mm
(76 mm with stopper)

181
Snuff bottle
c. 1780–1850
Amber, dark brown, carved with a continuous weave design, with ropework round the shoulders
46 × 43 × *c.* 23 mm
(56 mm with stopper)

go along with my recommendations; in fact, he would often surprise me. He simply had a strong mind of his own. He favoured organic bottles – those made from materials of animal and vegetable origin – a reflection of his love of nature. His taste was, in many ways, exactly where his feet remained – on the ground and connected with the world and all that was around him.

Ken and I always considered amber to be the 'friendliest' of all materials made into snuff bottles. Anyway, we both knew what we meant by that! Amber is the fossilized resin of coniferous trees from prehistoric forests. Snuff-bottle collectors tend to separate amber into three types, according to colour. If it is opaque yellow, it is called Baltic amber; if transparent or translucent reddish brown, it is called Burmese amber; if it has patches of rich, opaque brown or ochre-yellow, it is called root amber.

The Chinese, however, even from earliest times, have known amber as *hu po* (the soul of a tiger), a name deriving from the old Chinese belief that when a tiger dies its spirit enters the ground and is transformed into amber. This substance is therefore popularly regarded as a symbol of courage, as it is believed to be saturated with the qualities of that fierce animal. Proof that Ken was captivated by this material is that there are fourteen amber bottles in his collection (figs. 179, 180, 181).

It was a sign of Ken's discernment that he was so disciplined in his collecting. Ken could have had anything, but that would have been too

182
Snuff bottle, *c.* 1800–50
Hornbill, carved on each
edge with a writhing dragon
63 × 53 × *c.* 17 mm
(73 mm with stopper)

easy. There was always a limit, a line that he would not cross. For him, collecting was about enjoyment and a feeling that he simply could not leave behind those objects that excited him. He did not want to buy very expensive bottles; that was never meaningful for him. Sometimes, when I said something was "important," he would say that, unfortunately, it was not really so important to him. He wanted bottles for which he felt an affinity – that talked to him – and because he was very perceptive, with good taste and keen judgement, his collection is at once very personal and of indisputably high quality.

Ken's interest was broad, and it delighted him that the Chinese attempted to make snuff bottles from just about anything and everything available, but he was especially drawn to those made of organic materials. For example, he had a penchant for hornbill ivory, the golden-centred, red-to-crimson-edged casque of the helmeted hornbill, a huge bird – as big as a swan – native to Borneo. Old bottles in this material (figs. 182, 183) are exceedingly difficult to find, especially in good condition, as there were very few made, and they tend to split and crack from being kept in a dry atmosphere. Nevertheless, Ken succeeded in finding five of them. When I told him that hornbill bottles needed to be lubricated and explained that natural oil from the hand and face was most beneficial to their preservation, I lifted the bottle to my face, smoothed it around a little and then rubbed it with my hands. Ken found that so amusing that he took his first hornbill snuff bottle in his hands and immediately copied me.

I quote him on his love of miniaturization: "I like sculpture, and I like miniaturization. I look at a sculpture, and I think of the man who created this, starting with a block – just a block of, say, ivory or boxwood. How did he ever end up doing this? It defies my imagination When I was a kid, I used to whittle away on a piece of wood thinking I might get the shape of a head out of it or something. I never did get anything worth looking at, but at least, when I look back now, I had the potential to appreciate small sculpture

Of course, Ken did not limit his collection to bottles of organic substances. The range of materials made into snuff bottles is vast, and although it would be impossible to mention them all, a few of Ken's 'non-organic' acquisitions must be illustrated. He was very fond of porcelain figural bottles: the reclining lady (fig. 185) has a removable foot which serves as the stopper for removing the snuff.

Li Tie Guai (fig. 184), one of the Eight Immortals, is shown with his iron crutch and leaning against his bottle-gourd. The little boy (fig. 186) holds a large peach, which is an emblem of longevity.

Jadeite and nephrite are especially prized by the Chinese. Illustrated here are two especially lovely bottles from Ken's collection, a brilliant green jadeite bottle (fig. 187) and a pale nephrite bottle of unusual shape (fig. 188). Appreciation for hardstone bottles increases greatly when one

183
Snuff bottle

c. 1821–50
Hornbill, carved with a sage whose
attendant carries his lute, the reverse
with staff-carrying sage and attendant,
all amongst trees
63 × 54 × *c.* 18 mm
(73 mm with stopper)

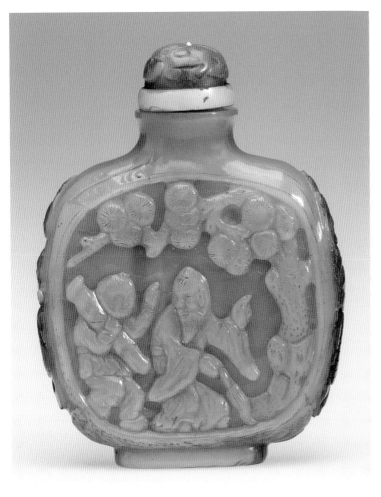
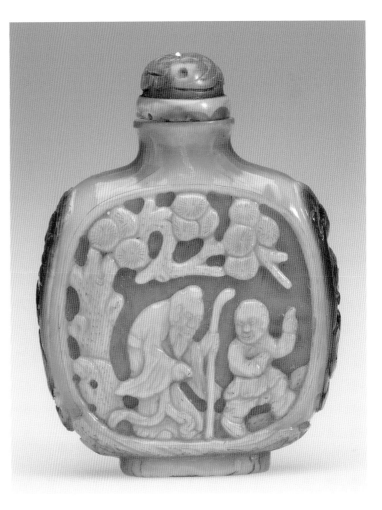

184
Snuff bottle as Li Tie Guai
c. 1780–1850
Porcelain, famille rose
colours
38 × 61 × 17 mm

185
**Snuff bottle as a reclining
woman**
c. 1780–1820
Porcelain, famille rose colours,
stopper in right foot
86 × 38 × *c.* 30 mm
(91 mm with stopper)

186
**Snuff bottle as a young boy
with a bib**
c. 1780–1820
Porcelain, famille rose colours,
and wood
Height 58 mm

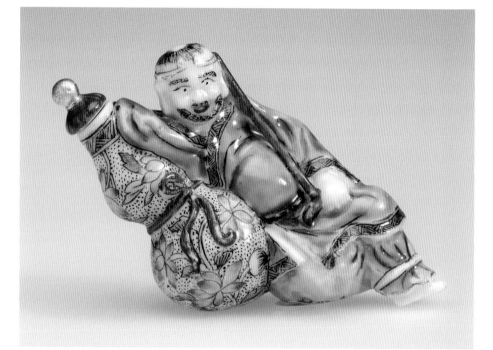

considers the painstaking work that has gone into their manufacture, especially with the traditional tools and methods used during the eighteenth and nineteenth centuries. The craftsmen had to cut the original blocks of stone into workable pieces before shaping the bottle, carving the design, hollowing out the interior, and then moving to the final stage of polishing. The hollowing of a bottle like that in fig. 187 would have been extremely difficult and time-consuming.

One more bottle in the Collection (fig. 189) is made of puddingstone, a distinctive kind of conglomerate consisting of quartz pebbles in a chert matrix, cemented together on a seashore or in a river bed many ages ago. Fig. 190 is a fine example of a Suzhou agate bottle. The lapidaries working in Suzhou, rose brilliantly to the challenge of using chalcedony's natural variations in colour to the best advantage. The dark brown inclusions here are skilfully used for the robes, hats and rockwork and also for the raised calligraphy.

For many people, the most amazing bottles are undoubtedly those painted on the inside (figs. 191, 192). Using a very fine sliver of bamboo as a brush, and working through the narrow opening at the mouth of the bottle, the artists painted a scene, working 'backwards,' on the inside wall of the bottle. The first inside-painted bottles – of glass, crystal or other translucent material – were painted at the very beginning of the nineteenth century, but this art reached its zenith one hundred years later. Some of the finest bottles are signed and dated, greatly adding to their desirablity and price. One bottle (fig. 192) showing different kinds of fish swimming amidst seaweed is remarkable because it conveys the idea of movement: the fish are not 'static,' and one can look at such a picture with pleasure for a long time.

187
Snuff bottle
c. 1780–1850
Jadeite, mottled green with translucent areas where the body has been well hollowed
70 × 40 × 19 mm

188
Snuff bottle
c. 1780–1850
Nephrite, pale lavender colour, the body carved with a continuous basket-weave pattern
64 × 50 × 33 mm

I believe that Ken rather enjoyed the idea that snuff bottles, his 'chosen subject,' were more or less off the beaten track for many of his friends, who considered them unusual objects for a collection. Ever since they became collectors' items outside China, it is true, there has been a common misconception that, with their small size and obvious functionality, snuff bottles do not rank very highly in the broader context of Chinese art. Nothing could be further from the truth. Snuff bottles embody in miniature all of China's fine arts, in addition to its legends, myths and folklore. It is characteristic of Chinese works of art that, even though they are executed on a small scale, they possess the excellence of craftsmanship found in much larger objects. Ken Thomson, an insightful man, recognized this intuitively.

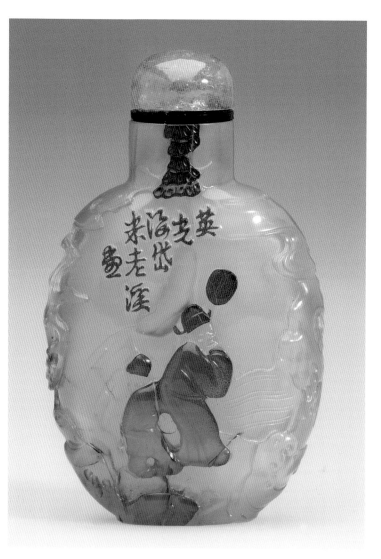

189
Snuff bottle
c. 1780–1850
Puddingstone, the quartz pebbles suspended in a chert matrix
53 × 46 × c. 27 mm
(65 mm with stopper)

190
Snuff bottle
c. 1780–1880
Chalcedony, pale beige with a darker brown skin, carved with a sage and his attendant in the rocky landscape, with raised inscription above
64 × 40 × 12 mm

191
MA SHAOXUAN
Snuff bottle, *c.* 1910
Glass, painted inside with a bear walking
between two trees, the reverse signed
and painted with a long inscription
63 × 40 × *c.* 19 mm

192
YE ZHONGSAN
Snuff bottle, 1910
Rock crystal, painted inside
with a continuous aquatic scene,
the reverse signed and dated
60 × 34 × *c.* 16 mm

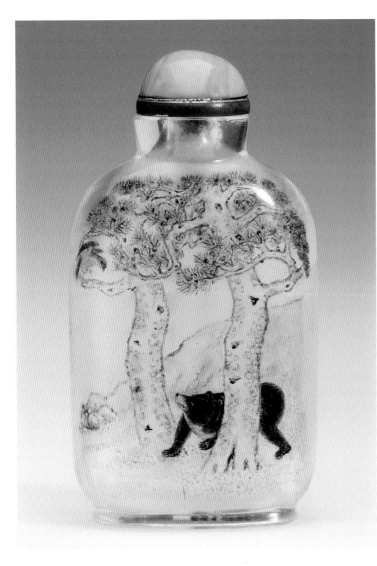

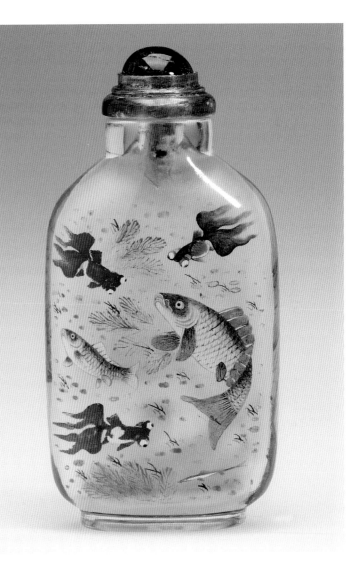

AUTHORS

ROBERT HALL is an art dealer specializing in Chinese snuff bottles.

ANNA HUDSON, previously Associate Curator of Canadian Art at the Art Gallery of Ontario, is an Assistant Professor at York University, Toronto.

GRAHAM REYNOLDS is former Keeper of the Department of Paintings, Drawings and Prints at the Victoria and Albert Museum, London.

CONAL SHIELDS, formerly Head of Art History and Conservation at the London Institute, is an authority on Constable and nineteenth-century English painting.

SIMON STEPHENS is Curator, Ship Model and Boat Collections, The National Maritime Museum, Greenwich, London.

ACKNOWLEDGEMENTS

Besides the authors and those listed here, a great number of people have given generously and selflessly of their time and expertise in the preparation of this series of volumes, among them Gemma Allen, Anastasia Apostolou, Barbara Butts, Christina Corsiglia, Lisa Ellis, Margaret Haupt, Greg Humeniuk, Ralph Ingleton, Christine Kralik, Melissa Potter, Emma Rutherford, Maria Sullivan, Marie-Eve Thibeault, Priyanka Vaid, Paul Wilson, Jennifer Withrow.

FRONT COVER

The images on the front cover are captioned in Conal Shields's essay, with the exception of the Northwest Coast (Tsimshian or Haida) portrait mask, c. 1840, and the ivory of the Virgin and Child, Paris (?), 1st half of the 14th century (?).

PHOTOGRAPHY

The photographs of works of art were taken by Matt Pia, London, UK
Michael Cullen, Peterborough, Ontario.

DVD

The DVD attached to this volume has been produced by Naked Creative Consultancy Inc., Toronto.

First published November 2008 by Skylet Publishing in association with the Art Gallery of Ontario

© 2008 Skylet Publishing / Art Gallery of Ontario Text and images of works of art © 2008 The Thomson Collection, Art Gallery of Ontario

Works by the following artists are reproduced in this volume and in Canadian Art, The Thomson Collection at the Art Gallery of Ontario respectively:
© Estate of Paul-Émile Borduas / SODRAC (2008)
Courtesy of The Estate of A.J. Casson
Courtesy of the family of Lawren S. Harris
Courtesy of the Estate of the late Dr Naomi Jackson Groves (A.Y. Jackson)
© The Estate of William Kurelek
© 2008 Estate of Arthur Lismer
© 2008 Estate of David Milne
© Varley Art Gallery, Town of Markham

All other images © Thomson Collection Archive and David Thomson Archive.

ISBN 9781903470 79 4
 9781903470 86 2 (5 volume boxed set)

Distributed in Canada by University of British Columbia Press
www.ubcpress.ca
and in the United States by the University of Washington Press
www.washington.edu/uwpress/
and in Europe and elsewhere by Paul Holberton publishing
www.paul-holberton.net

Produced by Paul Holberton publishing, London
www.paul-holberton.net

Designed by Philip Lewis

Origination and printing by e-graphic, Verona, Italy